D1211472

# BALTHUS

# BALTHUS

Stanislas Klossowski de Rola

Icon Editions

1817

**HARPER & ROW, PUBLISHERS, New York**

Cambridge, Philadelphia, San Francisco, London

Mexico City, São Paulo, Sydney

O
ND
553
.B23
A4
1983b

## Acknowledgments

The author and the original publishers would like to express their thanks to Pierre Matisse, Henriette Gomès and David Somerset for their invaluable help in the collection of picture material for this book, as well as to all the private individuals and institutions who have kindly given permission to reproduce paintings in their collections. In addition, the author would very much like to thank John Chesshyre for his help and collaboration in the preparation of the book.

BALTHUS. Copyright © 1983 by Thames and Hudson Ltd, London. Artistic works copyright © 1983 by Balthus Klossowski de Rola. All rights reserved. Printed in the Netherlands. No part of this book may be used or reproduced in any manner whatsoever without written permission except in the case of brief quotations embodied in critical articles and reviews. For information address Harper & Row, Publishers, Inc., 10 East 53rd Street, New York, N.Y. 10022. Published simultaneously in Canada by Fitzhenry & Whiteside Limited, Toronto.

FIRST U.S. EDITION

ISBN: 0-06-431275-5

LIBRARY OF CONGRESS CATALOGUE CARD NUMBER: 82-48579

83 84 85 86 87 10 9 8 7 6 5 4 3 2 1

DABNEY LANCASTER LIBRARY
LONGWOOD COLLEGE
FARMVILLE, VIRGINIA 23901

# Introduction

> '*L'artiste reproche tout d'abord à la critique de ne*
> *pouvoir rien enseigner au bourgeois, qui ne veut ni*
> *peindre ni rimer, – ni à l'art, puisque c'est de ses*
> *entrailles que la critique est sortie. Et pourtant que*
> *d'artistes de ce temps-ci doivent à elle seule leur pauvre*
> *renommée! C'est peut-être là le vrai reproche à lui faire.'*
>
> CHARLES BAUDELAIRE

If things were as they ought to be, the present book should not warrant even a word of introduction, as it is a book of pictures and not a book of words about pictures. Indeed, such pictures should be looked at – and seen – not read about, or read into. Essentially, that is why Balthus, pressed for biographical details by John Russell (when the latter was writing the text to the catalogue of the Tate Gallery Exhibition in 1968) cabled him:

> NO BIOGRAPHICAL DETAILS.
> BEGIN: BALTHUS IS A PAINTER
> OF WHOM NOTHING IS KNOWN.
> NOW LET US LOOK AT THE
> PICTURES. REGARDS. B.

Needless to say, art critics and art historians generally feel otherwise. They dearly love to dissect every available shred of biographical information in a misguided search for revealing clues explaining Balthus's work. They are also fond of displaying their knowledge of art by tracing – to often outlandish sources – the heraldic lineage of a composition. Furthermore, in a few extreme cases they speculate recklessly on the situations, or predicaments, that they believe the subjects of the paintings to be in. Such unbridled flights of fancy are not only laughable, they contribute very little to the true appreciation of art. This, the philosopher A. K. Coomaraswamy warns us, 'must not be confused with a psycho-analysis of our likes and dislikes dignified by the name of "aesthetic reactions" . . . The study of art, if it is to have any cultural value, will demand two far more difficult operations than this, in the first place an understanding

7

and acceptance of the whole point of view from which the necessity for the work arose, and in the second place a bringing to life in ourselves of the form in which the artist conceived the work and by which he judged it. The student of art must be able to elevate his own levels of reference from those of observation to that of the vision of ideal forms. He must rather love than be curious about the subject of his study.'

In order to avoid the depressing misunderstandings which seem, almost unavoidably, to prevail even among those who most loudly clamour to be counted among Balthus's greatest admirers, the lover of his art should strive to contemplate the paintings. By 'contemplation' I mean the elevation from mere perusal and observation to vision, from the empirical to the ideal – a state wherein the act of seeing, the seen and the seer become one. Thus, having overcome the superficial handicap of his 'aesthetic reactions' (described by the anthropologist R. Firth as 'an excrescence upon a genuine interest in art which seems peculiar to civilized peoples'), the spectator is able to penetrate the true meaning of the work and thus truly to judge it. Any other way is doomed to failure, for Balthus's art pertains to a mysterious tradition whose secret and sacred tenets he is constantly in the process of rediscovering. His path, from early childhood, seems always to have been directed by fate in that very direction. Rainer Maria Rilke marvelled in a letter written in 1922 at 'this boy, so strangely oriented towards the East' . . .'When we went to see him at Beatenberg in September, he was just painting Chinese lanterns, with a flair for the oriental world of form that is amazing. Then we read the little Book of Tea: one can't imagine where he gets all his assured knowledge of Chinese Imperial and artistic dynasties . . .'

Nevertheless, Balthus's artistic progress has been far from easy. The basic craft of painting, its techniques, trade secrets, and attendant skills – which in former times could be learned in the studio of a master – Balthus has had to teach himself through trial and error, pursuing relentlessly a mastery which, even today, still partly eludes him and often reduces him to despair. He compares the task imposed upon him by the inner compulsion of his yearning to

trying to write without possessing the vocabulary required to express oneself. The language of painting must therefore be painstakingly reinvented, and its art constantly rediscovered.

The stages of Balthus's artistic evolution led him from his faltering first steps to the necessity of trying in his work to seize at all costs what appears to be reality. The means he employed in his delusive search for greater realism were, to begin with, more akin to drawing than to painting. But as the vision evolved, the seeds of doubt began to sprout, and the painter, like the alchemist awaiting the long delayed promise of dawn, felt the very nature of the *seen* escaping him more and more. Such an exacting tribute inevitably had to be paid, before the ripening of experience could allow a kind of magical transfusion to take place, and the transmutation of his efforts into painting could occur. In his recent works (which take longer and longer to complete), Balthus achieves in contrasting hues of incredible subtlety a strange hieratic intensity. However, far from being satisfied, far from being complacent, and far from having exhausted his potential, Balthus, constantly evolving, is propelled forward on a quest – which he nevertheless qualifies as hopeless – dreaming of an elusive, unknown ideal that he is far from being confident of reaching.

But this pessimism may be unjustified. In the words of the *Bhagavad Gîta*, 'the man devoted to his own vocation finds perfection . . . That man, whose prayer and praise of God are in the doing of his own work perfects himself.' And in the *Asclepius* of Hermes Trismegistus it is said that 'if a man takes upon him in all its fullness the proper office of his own vocation [*curam propriam diligentiae suae*], it is brought about that both he and the world are the means of right order to one another. For since the world is God's handiwork, he who maintains and heightens its beauty by his tendance [*diligentia*] is co-operating with the will of God . . . What shall be his reward? That when we are retired from office [*emeritos*] God will restore us to the nature of our better part which is divine.'

Perhaps here is as good a place as any to point out that the fabled theme of the young adolescent girl, which Balthus has treated repeatedly, has nothing

whatsoever to do with sexual obsession except perhaps in the eye of the beholder. These girls are in fact emblematic archetypes belonging to another, higher realm. Their very youth is the symbol of an ageless body of glory, as adolescence (from the Latin *adolescere*: to grow toward) aptly symbolizes that heavenward state of growth which Plato refers to in the *Timaeus*. Eroticism is nowadays confused with libidinousness, thus obscuring the true intelligence of esoteric works ultimately pertaining to the divine cosmic mystery of love and desire.

It may well be that my words will greatly disappoint those learned pundits who rejoice in their own opinionated fantasies about Balthus and the meaning of his art. But those eminent members of the self-styled international cultural élite value art essentially as the self-revelation or self-expression of the artist. Despite the fact that their concern lies rather with styles, dates and influences than with his true intentions, they seek – in a pseudo-psychological way – to explain everything, thus substituting the study of the artist himself for the study of his art. Although the characteristic feature of their discourses is meaninglessness, 'these leaders of the blind', as Coomaraswamy aptly calls them, 'are gladly followed by a majority of modern artists, who are naturally flattered by the importance attached to personal genius.'

Balthus, by contrast, dislikes being written about and has always kept out of the limelight. He staunchly refuses to grant interviews of any kind, to make declarations or to submit to the sort of exhibitionism that has come to be expected from a modern artist. He aspires instead to the anonymous perfection of the man liberated from the burden of himself. For this purpose he sees both his individuality and his work as a means, not as an end.

*Plates*

*Author's note:* No 'story-telling' element should be derived from the titles of the works, which have been given for the purposes of identification only and rarely by Balthus himself.

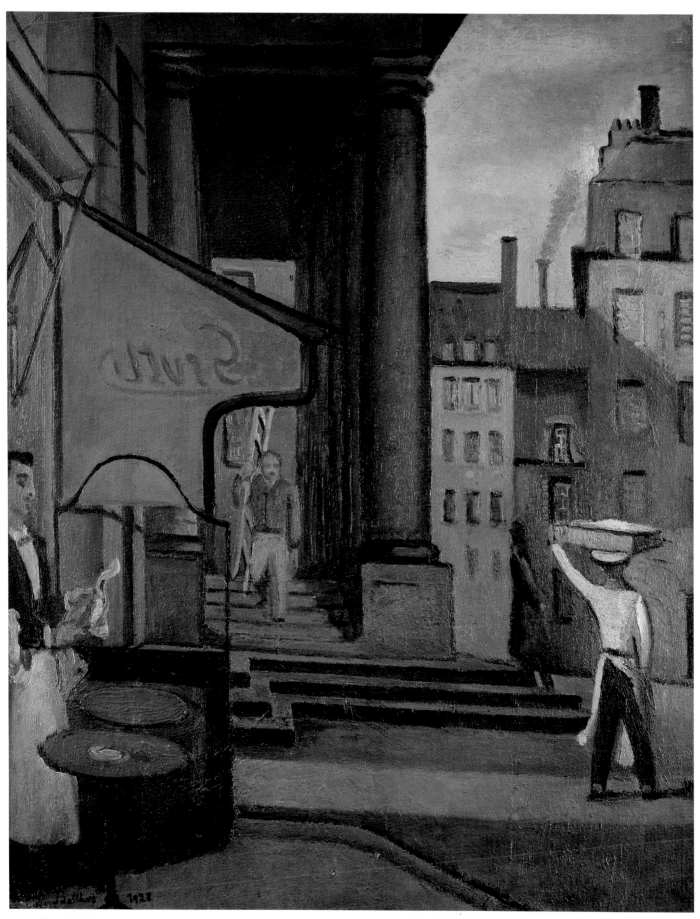

1 *Café de l'Odéon* 1928

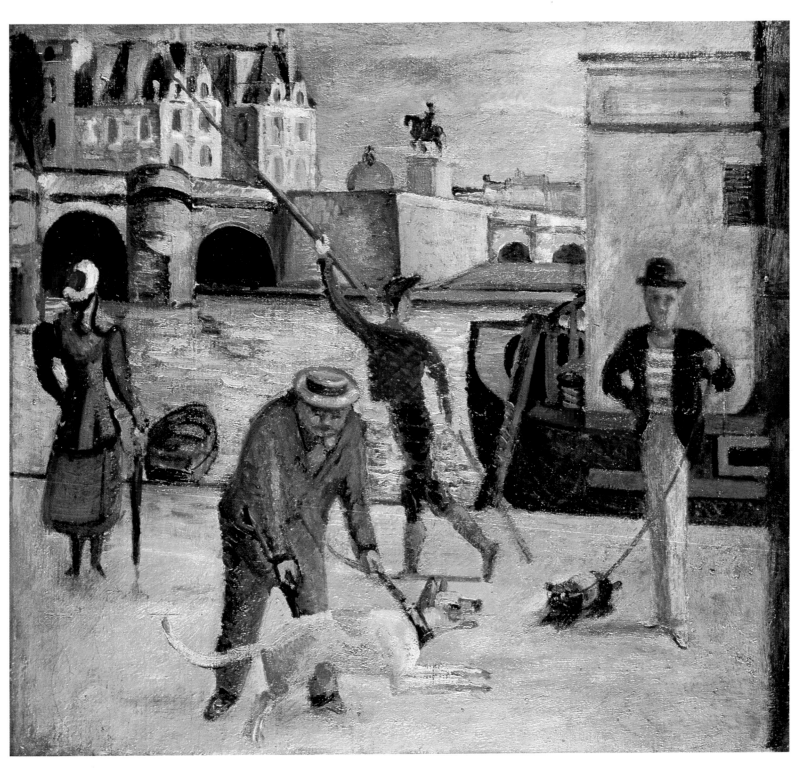

2  *Le Pont Neuf*  *c.*1927

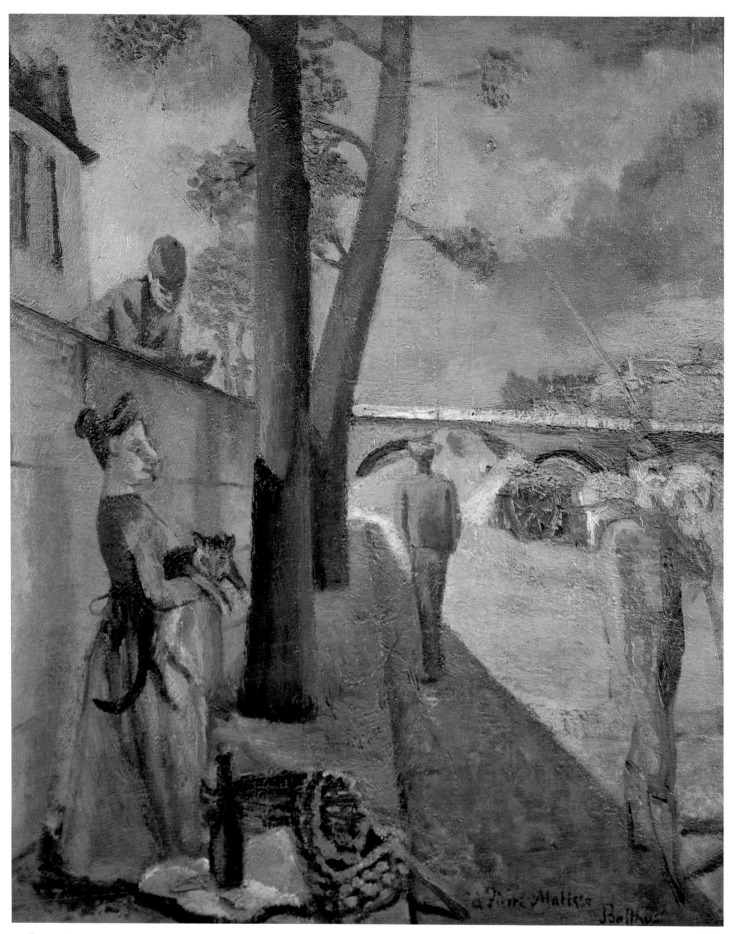

3　*Les quais*　1929

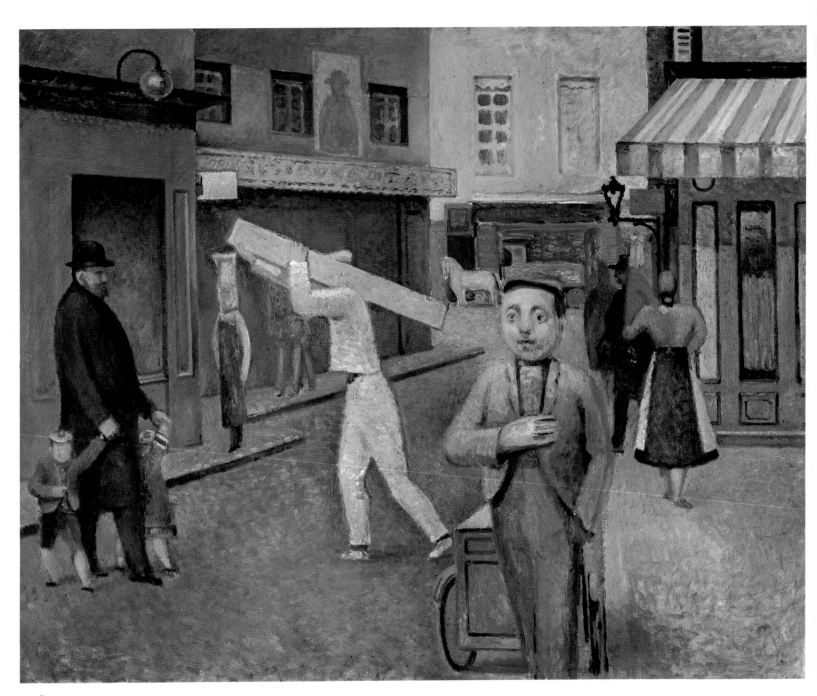

4   *La rue*   1929

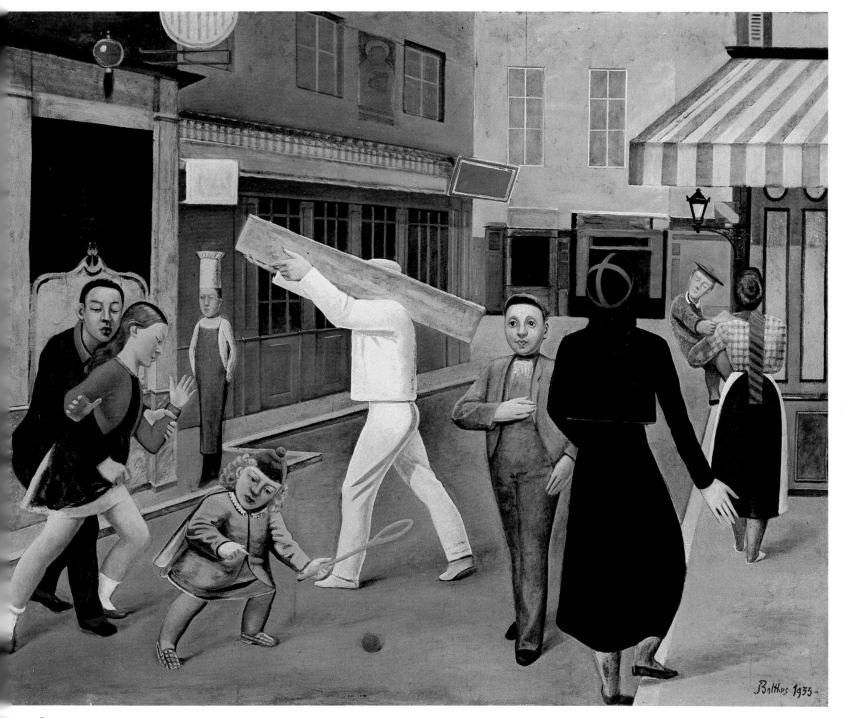

6–7  *La rue*  1933–35

6, 7 >

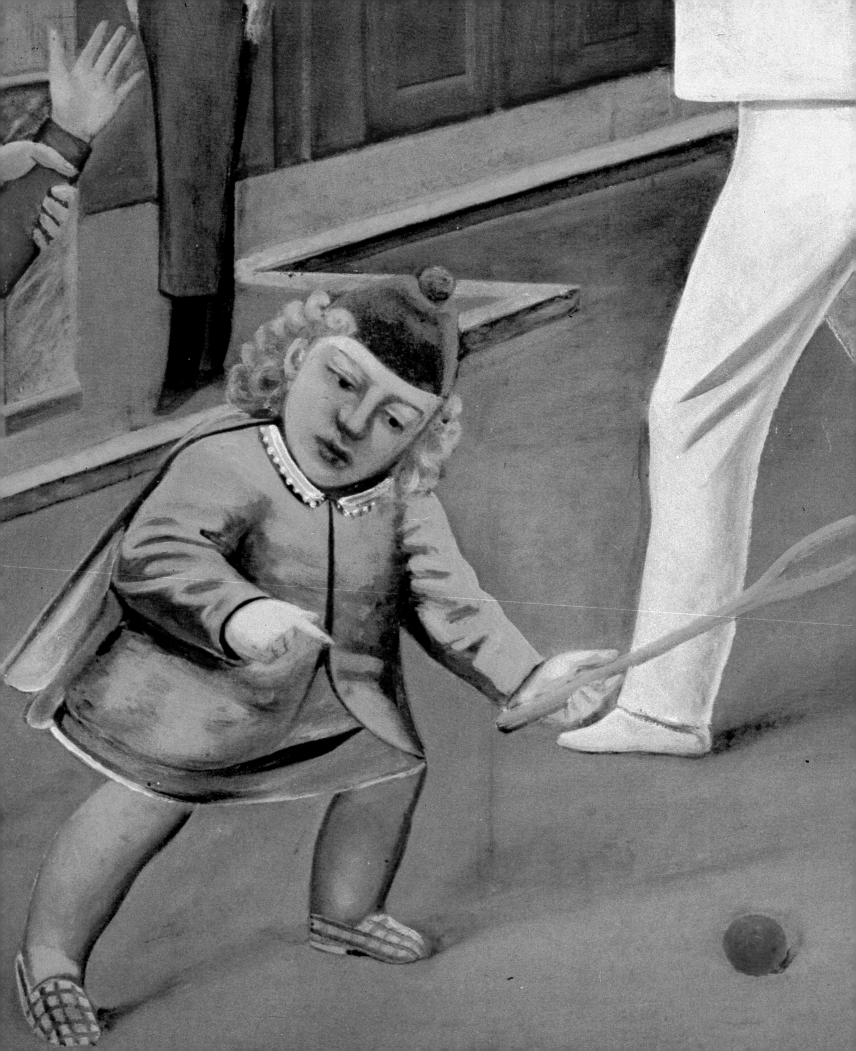

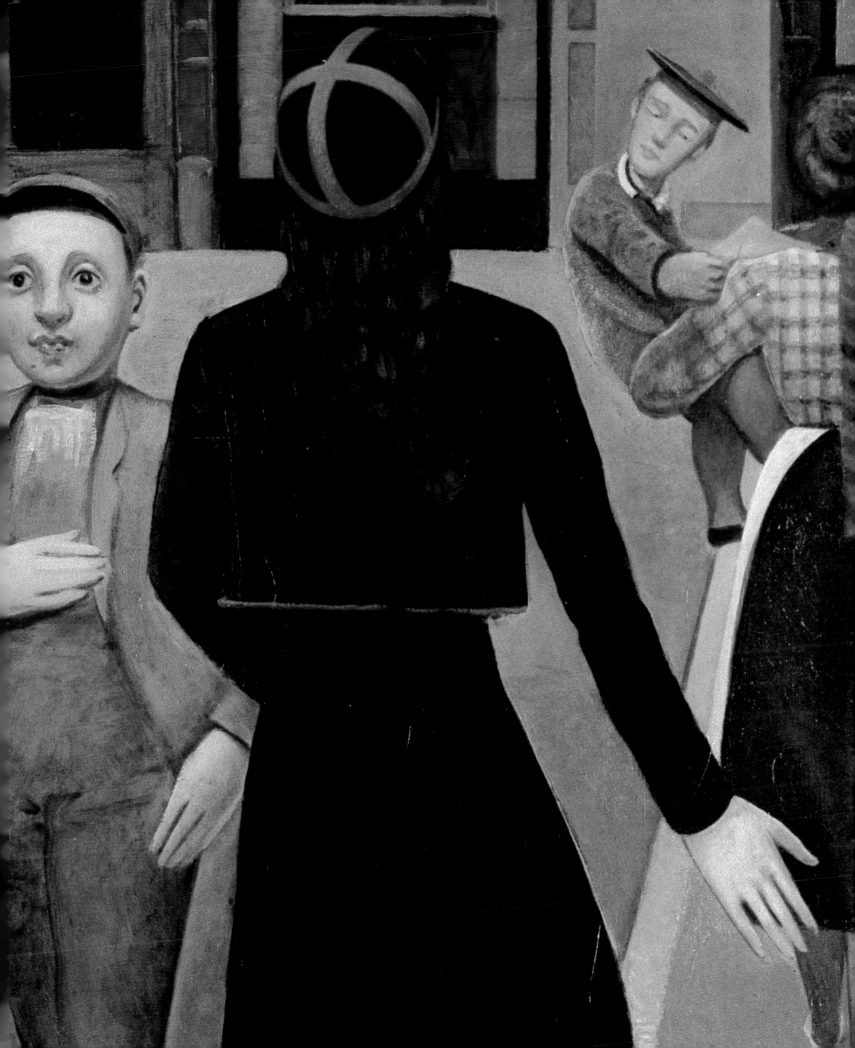

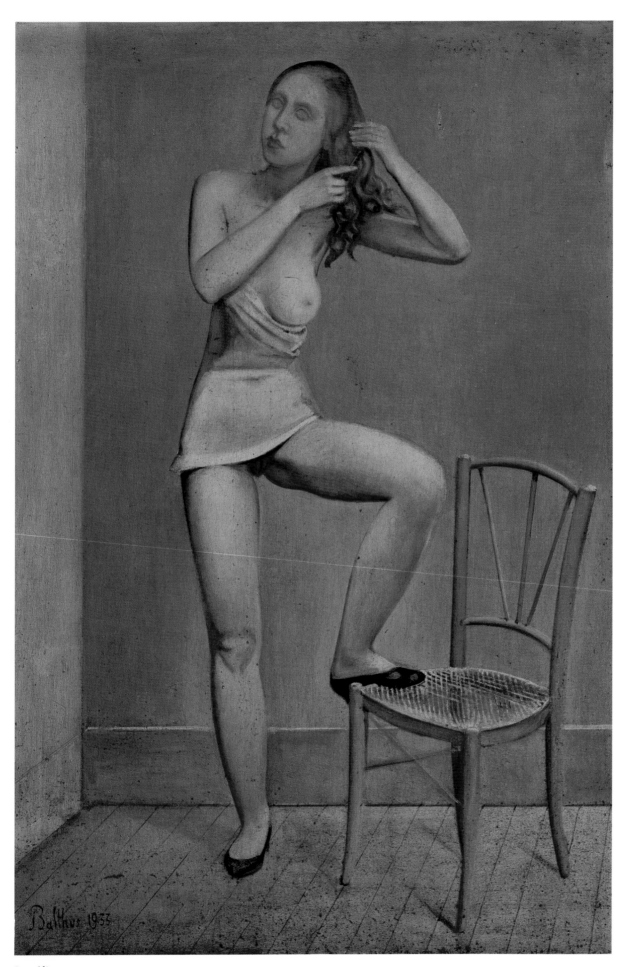

8 *Alice* 1933

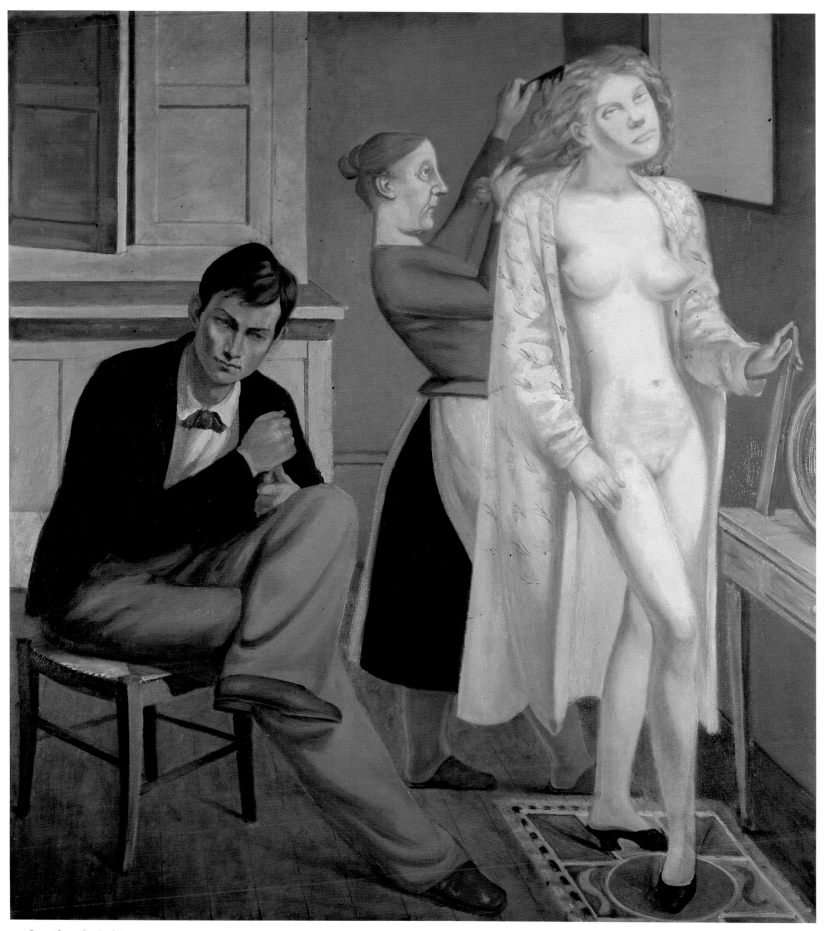

9   *La toilette de Cathie*   1933

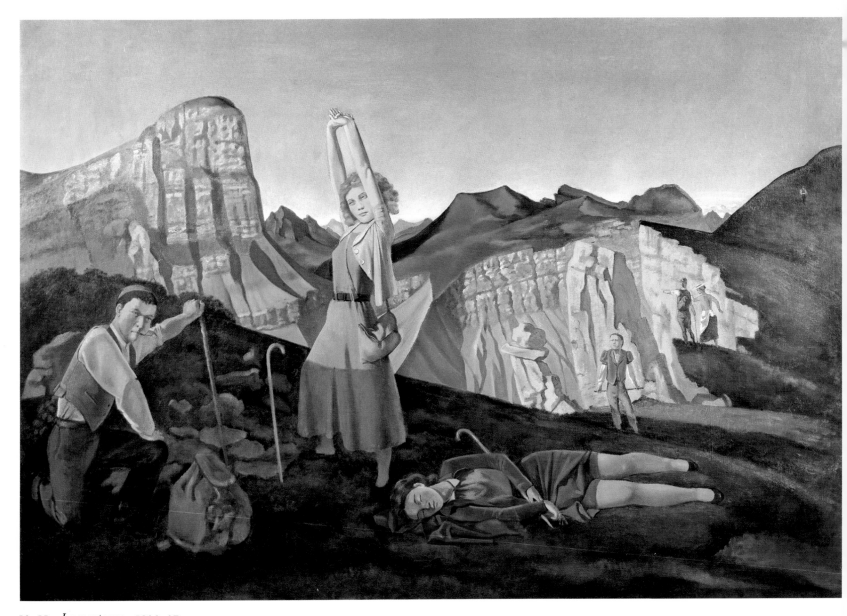

10, 11  *La montagne*  1935–37

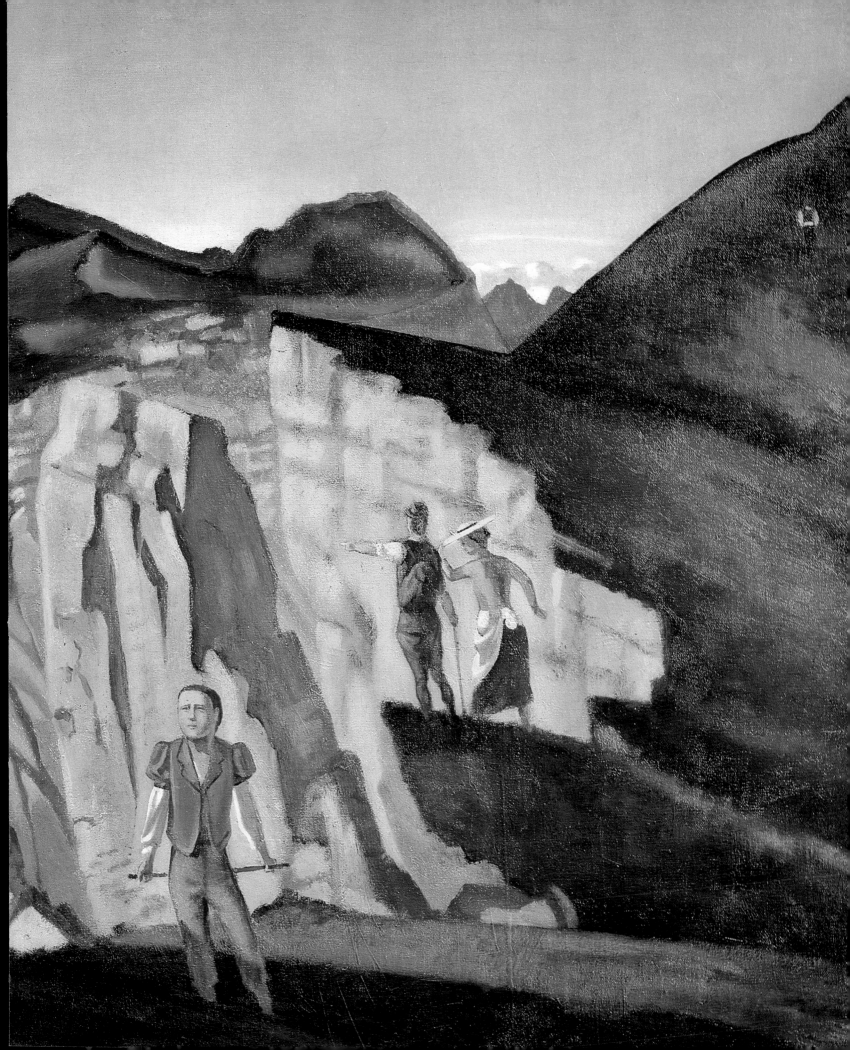

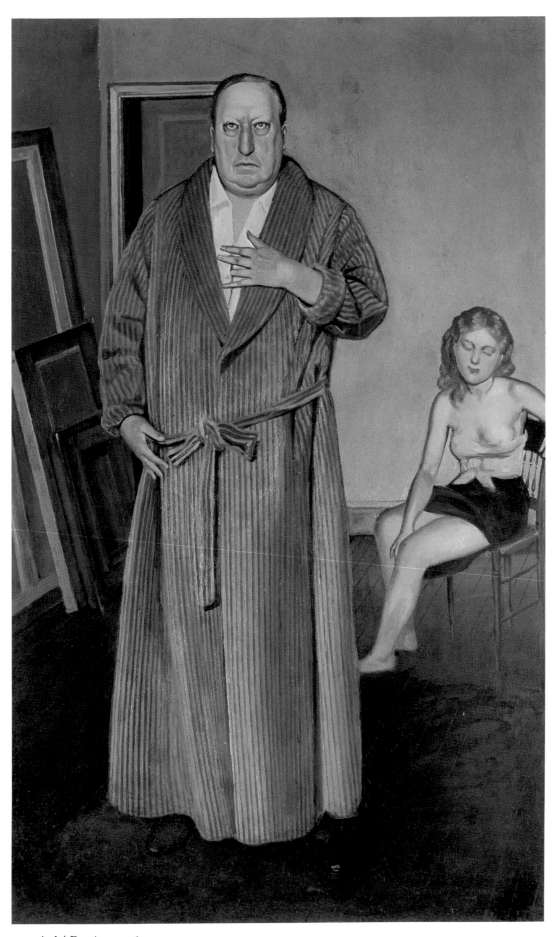

12   *André Derain*   1936

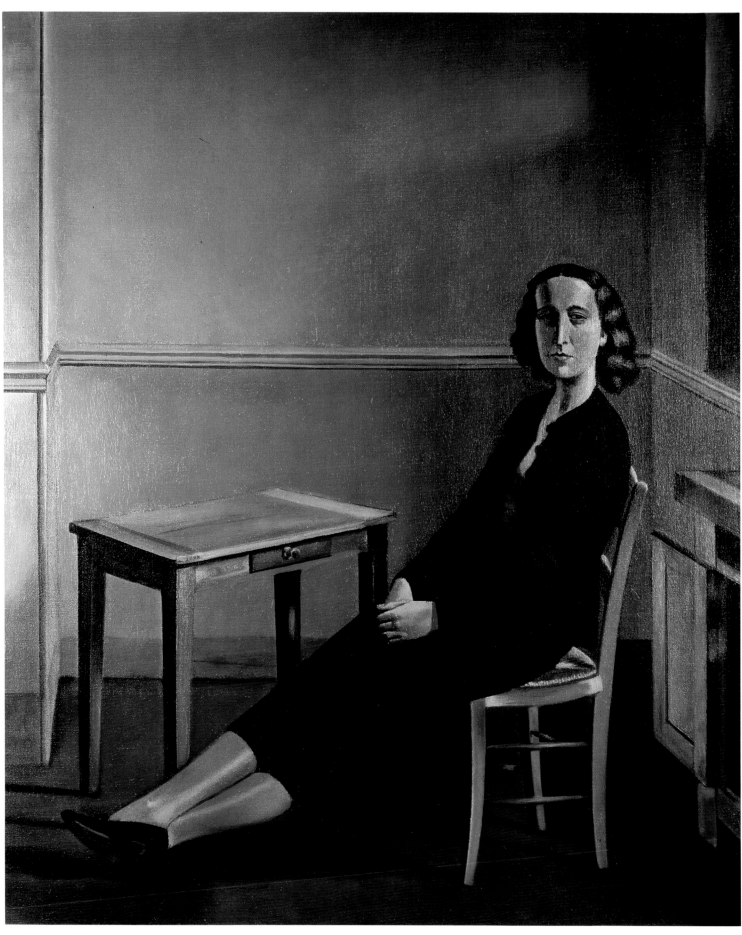

13   *Portrait de la Vicomtesse de Noailles*   1936

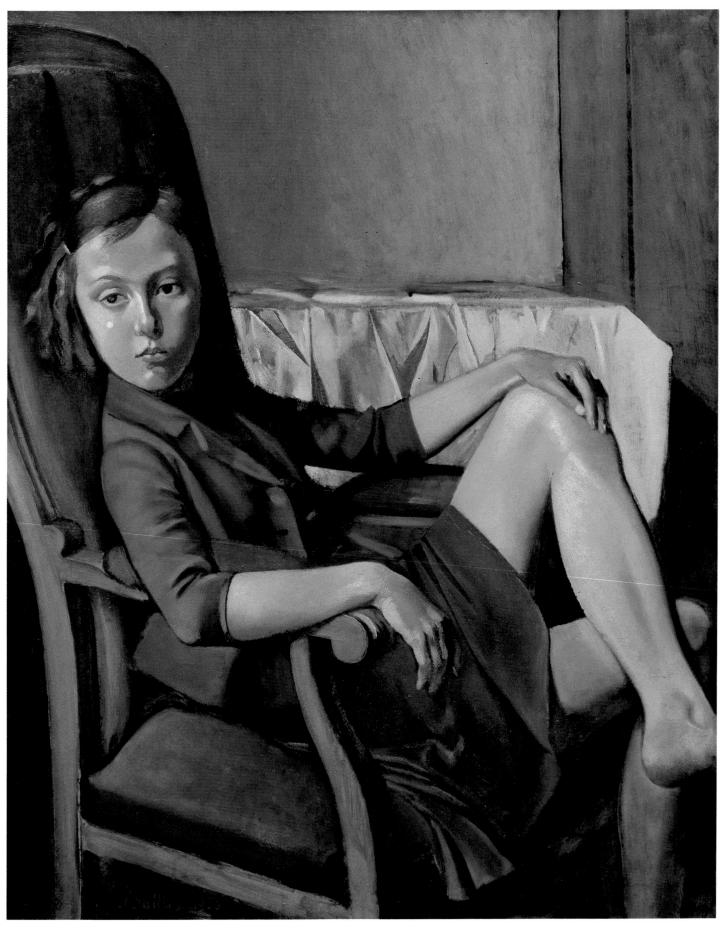

14  *Thérèse*  1938

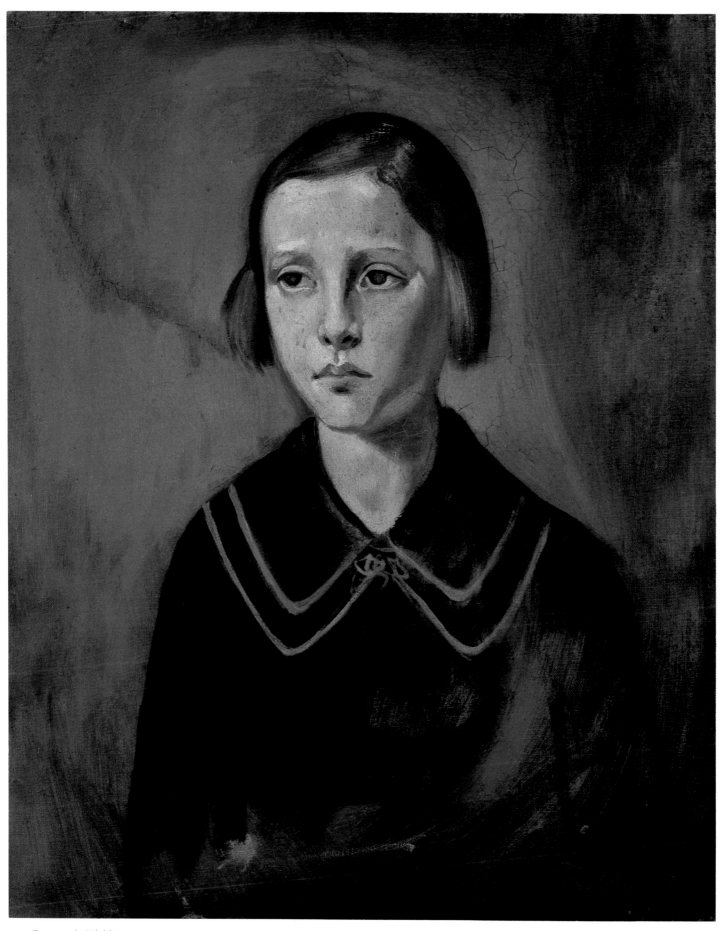

15  *Portrait de Thérèse*  1936

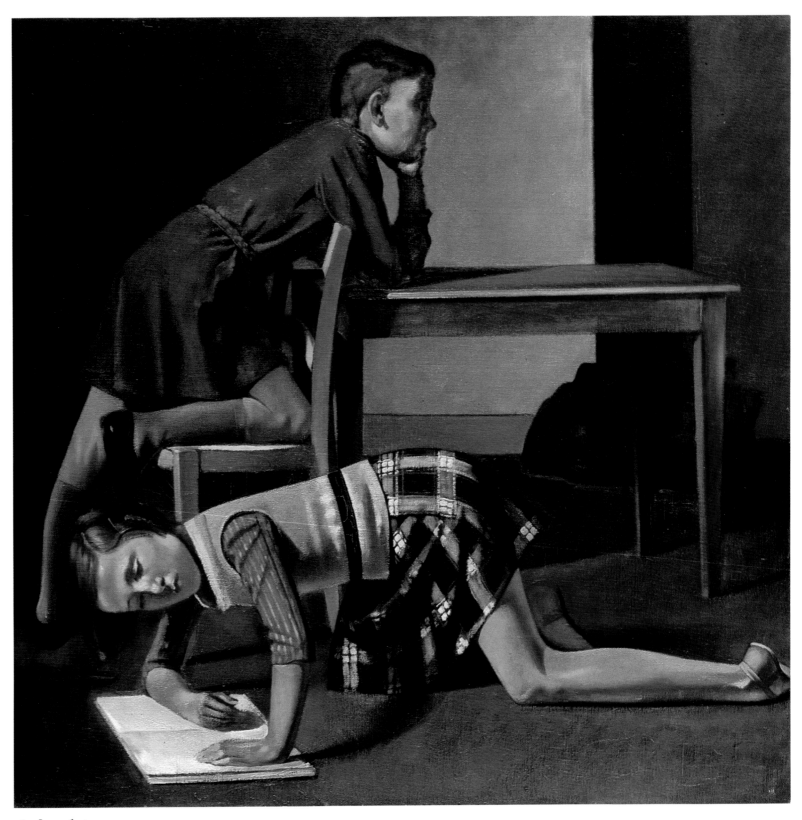

16    *Les enfants*    1937

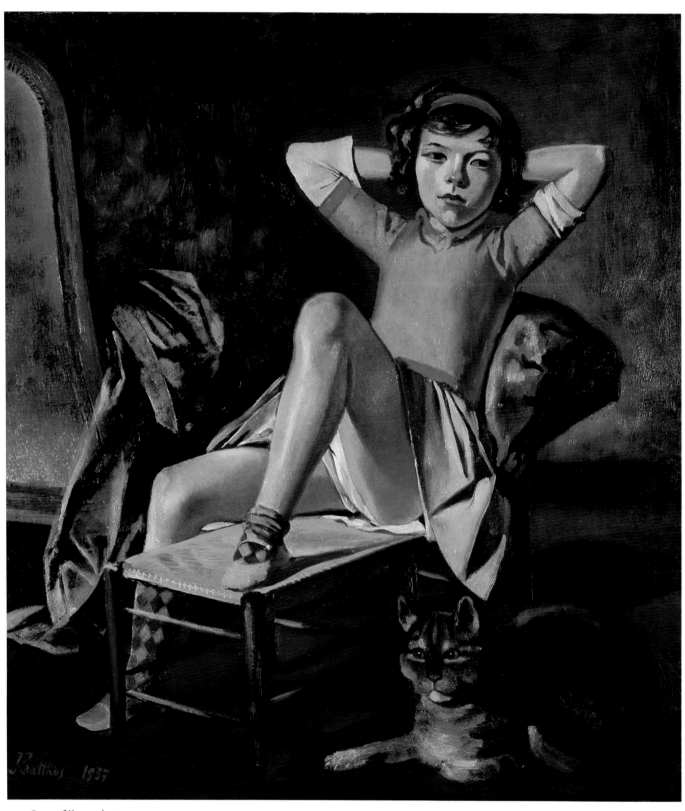

17 *Jeune fille au chat* 1937

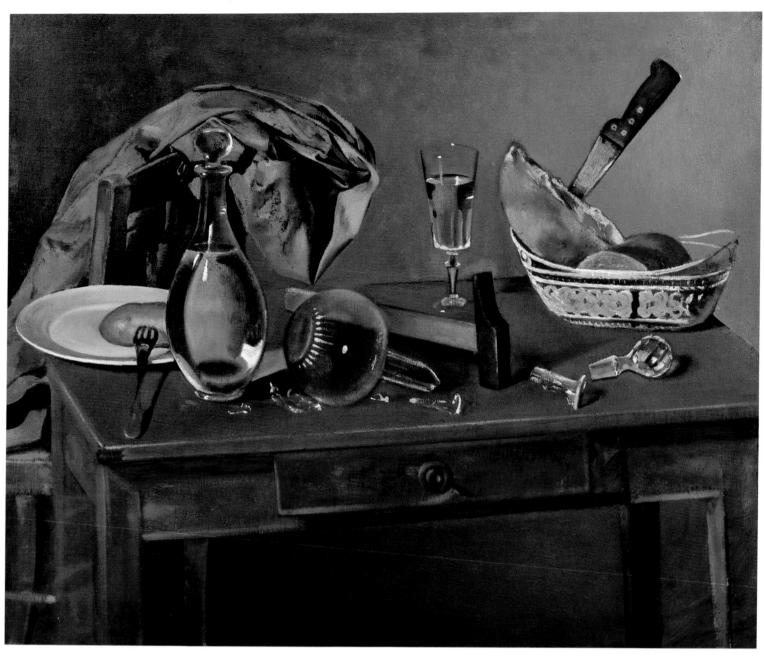

18    *Nature morte*    1937

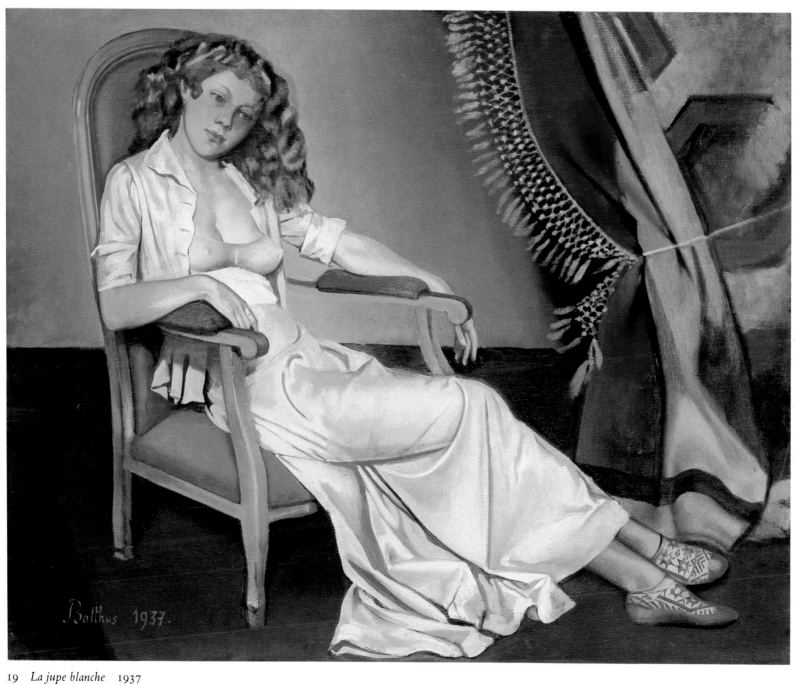

19   *La jupe blanche*   1937

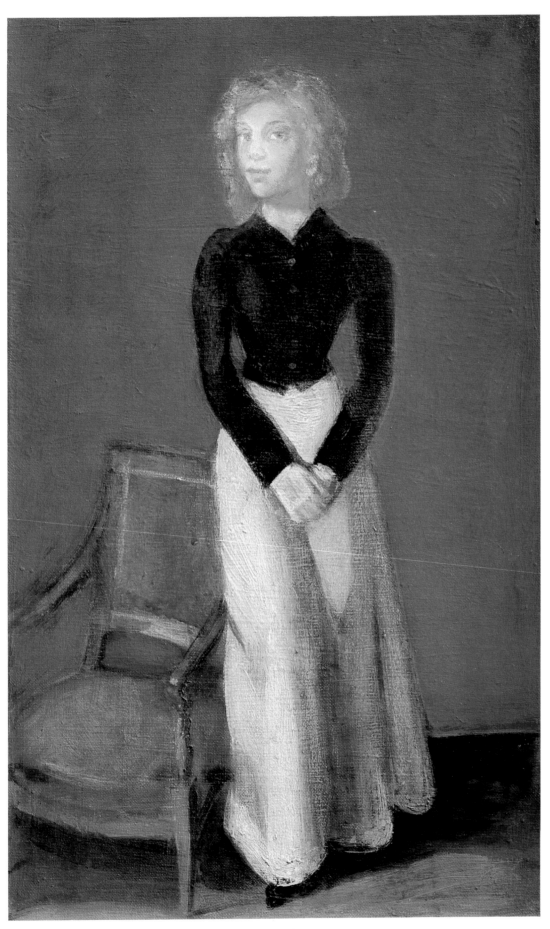

20  *Portrait d'une jeune fille en costume d'amazone*  1932/81

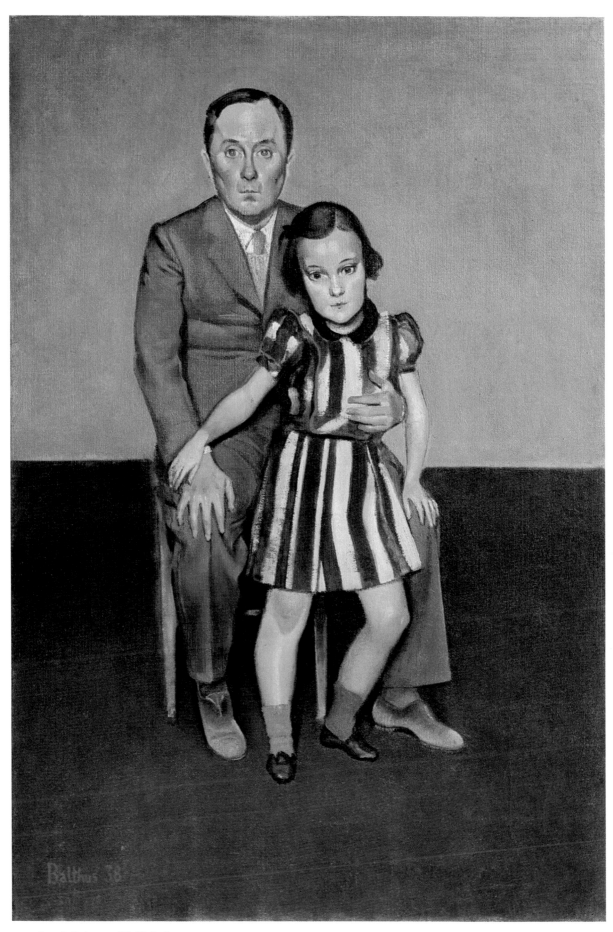

21  *Joan Miró et sa fille Dolorès*  1937–38

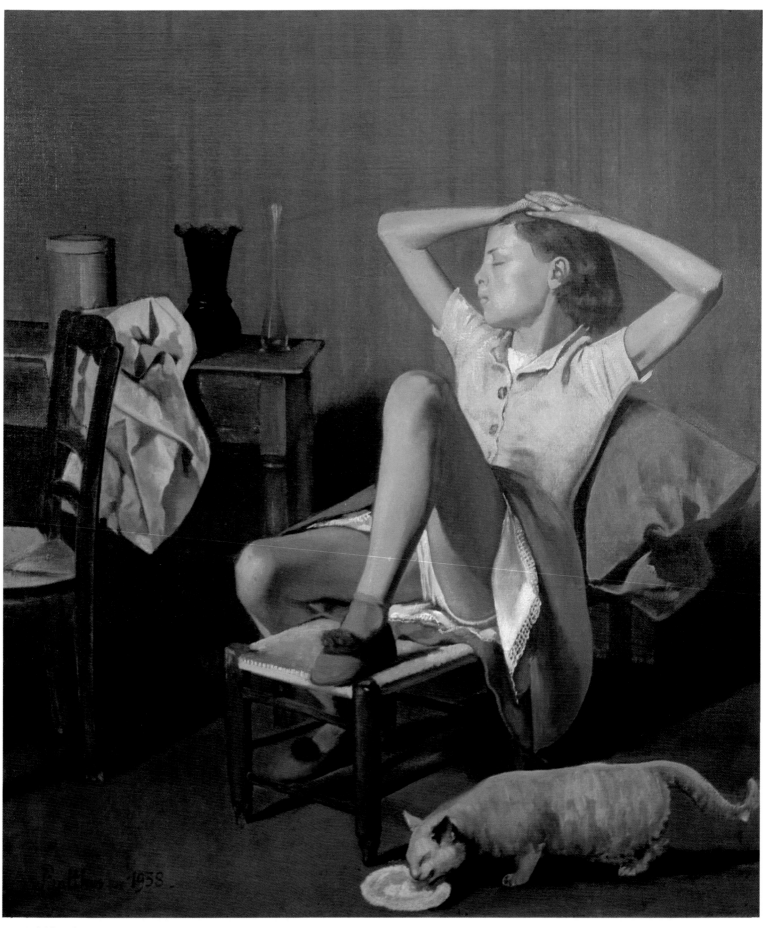

22  *Thérèse rêvant*  1938

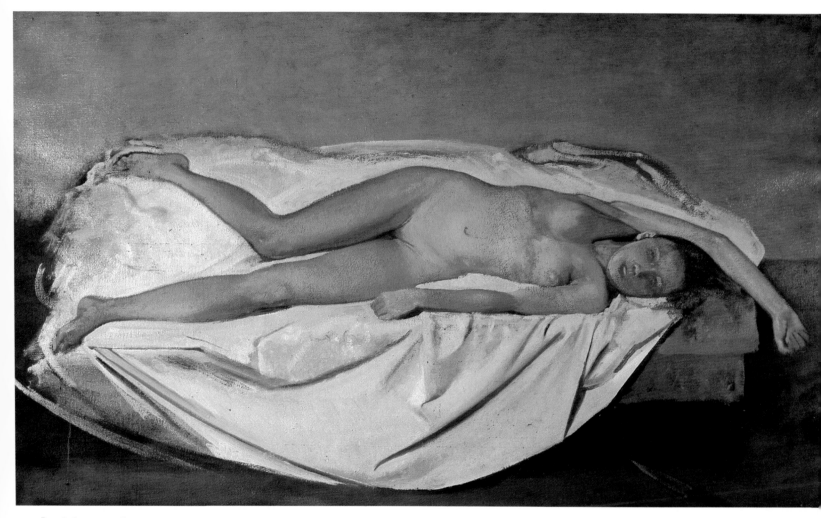

23　*La victime*　1938

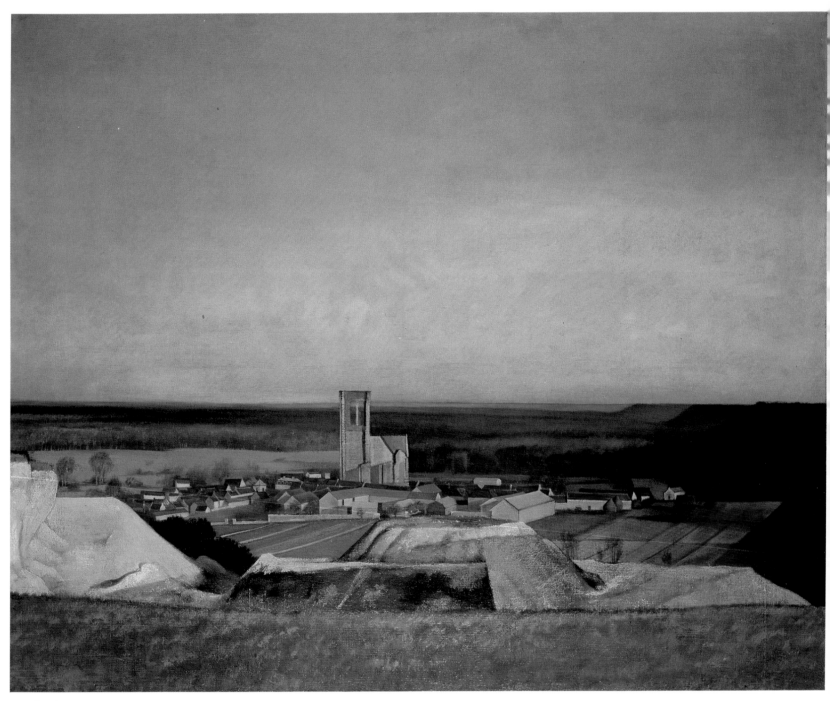

24   *Larchant*   1939

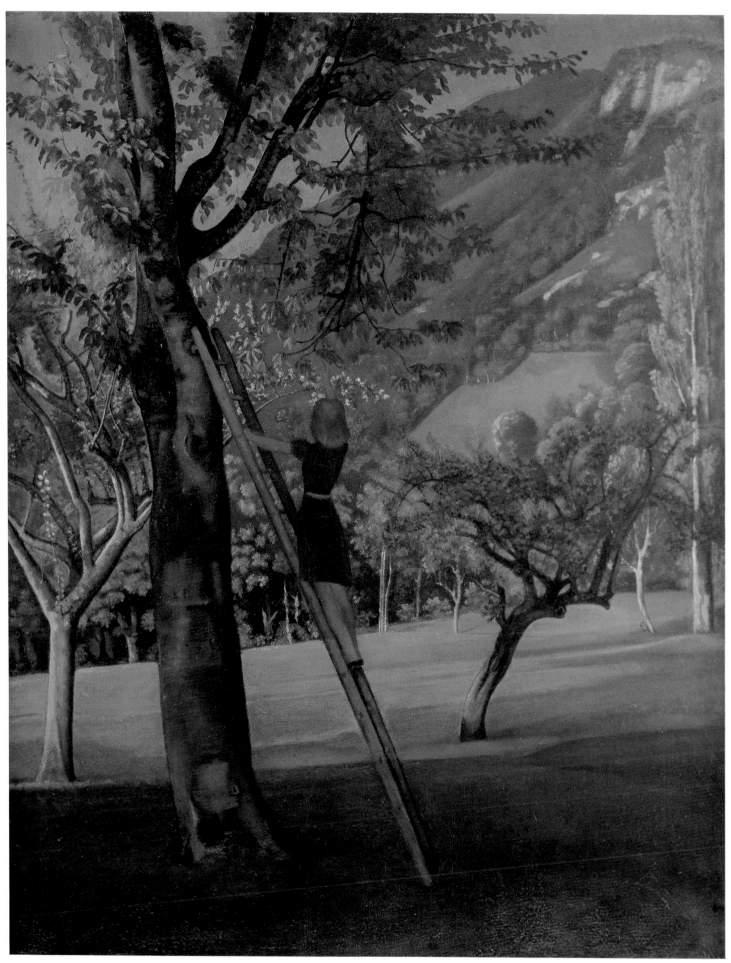

25  *Le cerisier*  1942

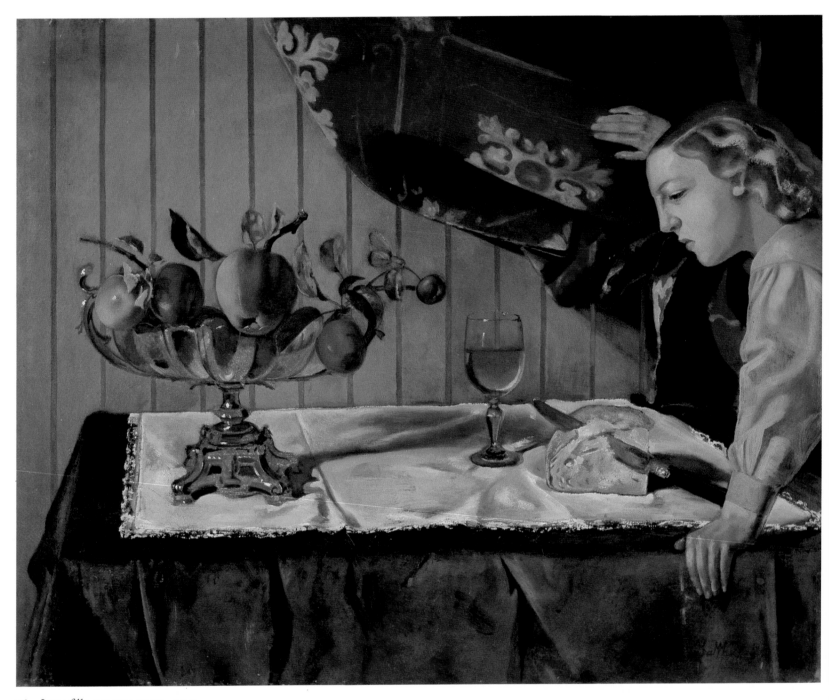

26   *Jeune fille et nature morte*   1942

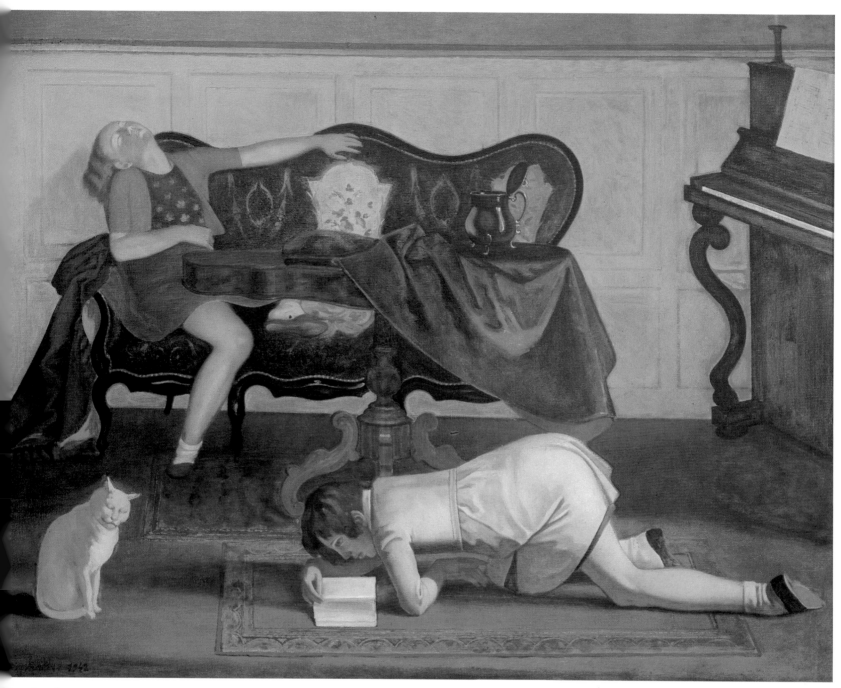

7   *Le salon*   1942–47

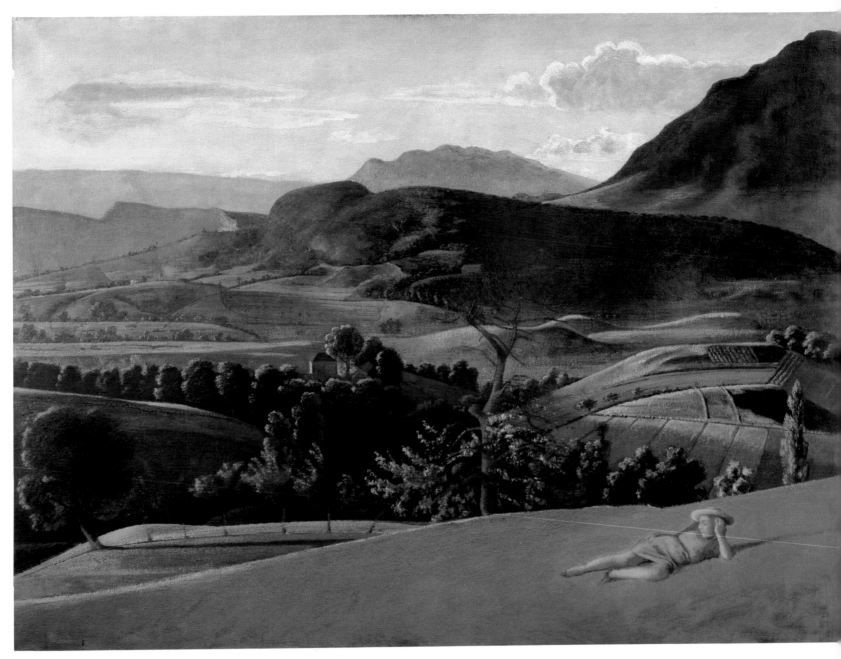

28, 29  *Paysage de Champrovent*  1942–45

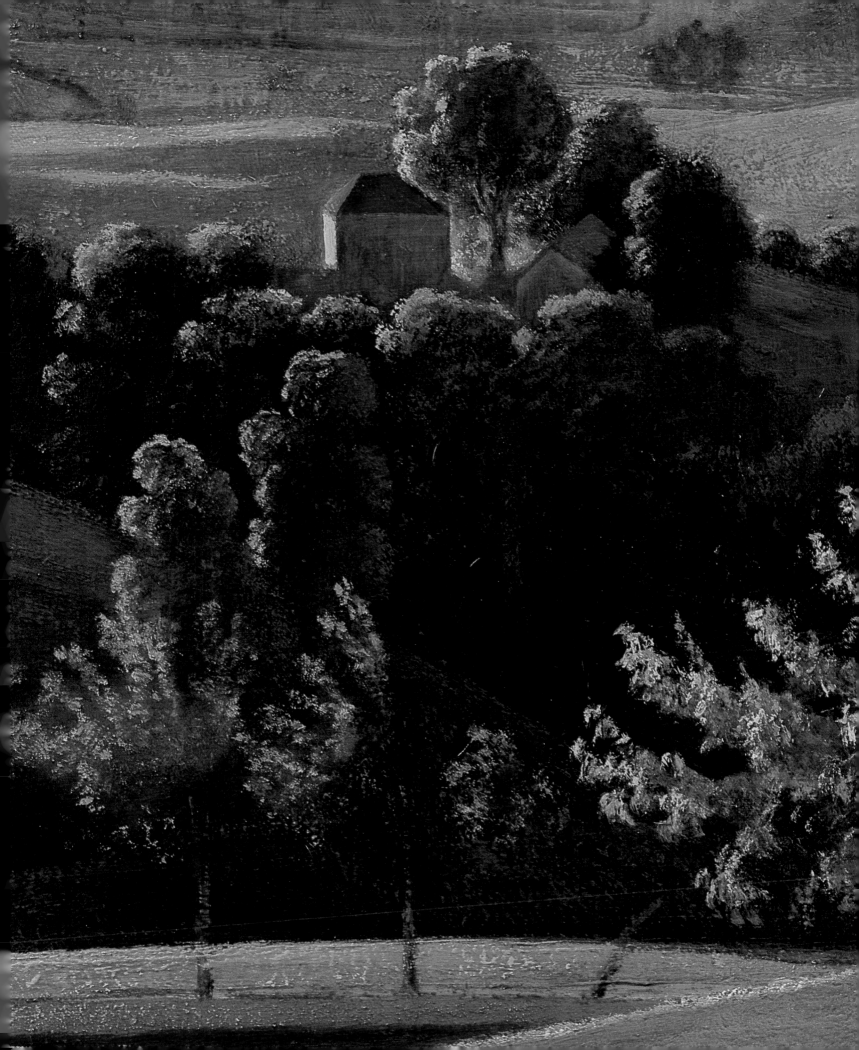

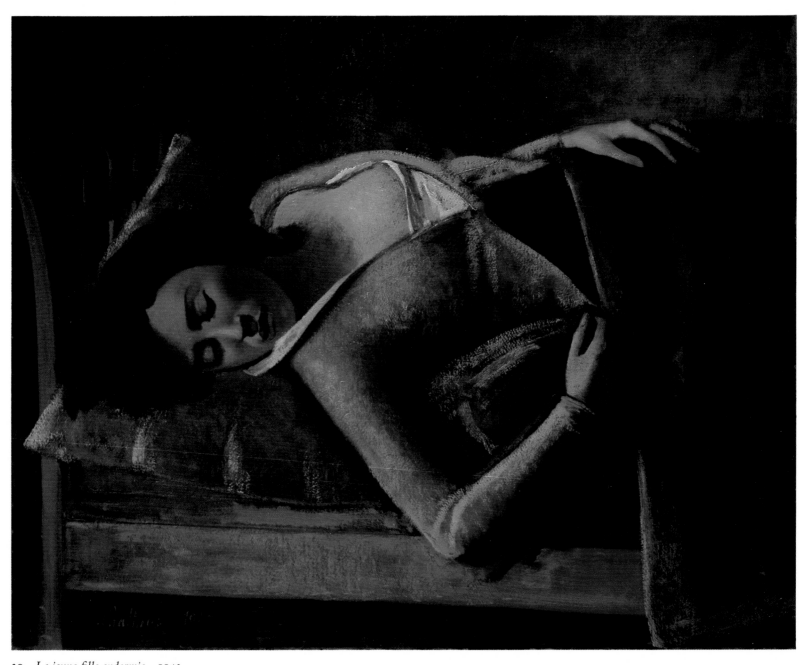

30　*La jeune fille endormie*　1943

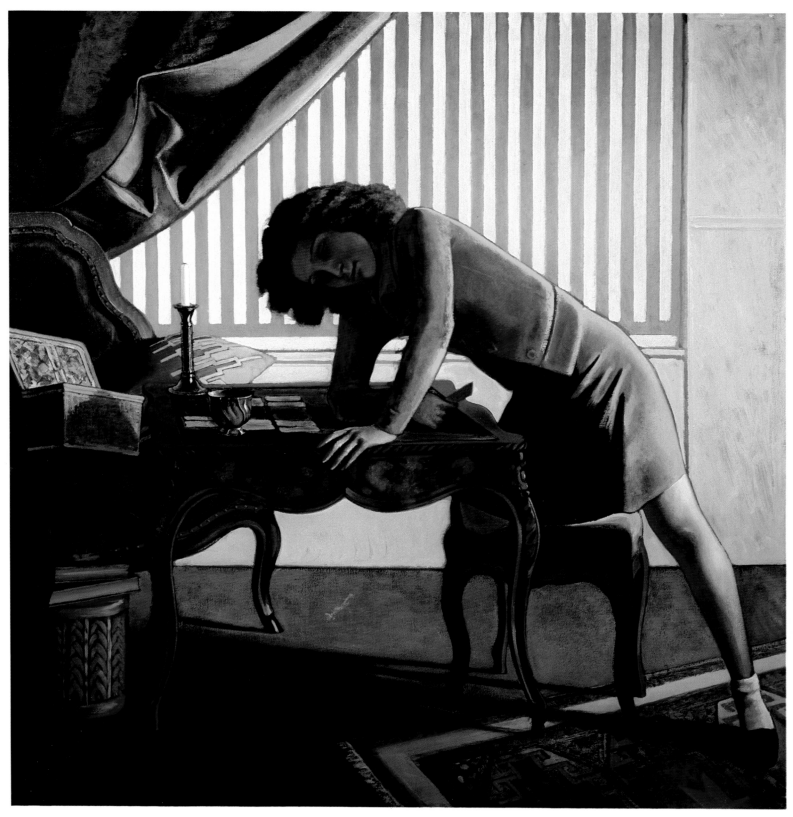

31  *La patience*  1943

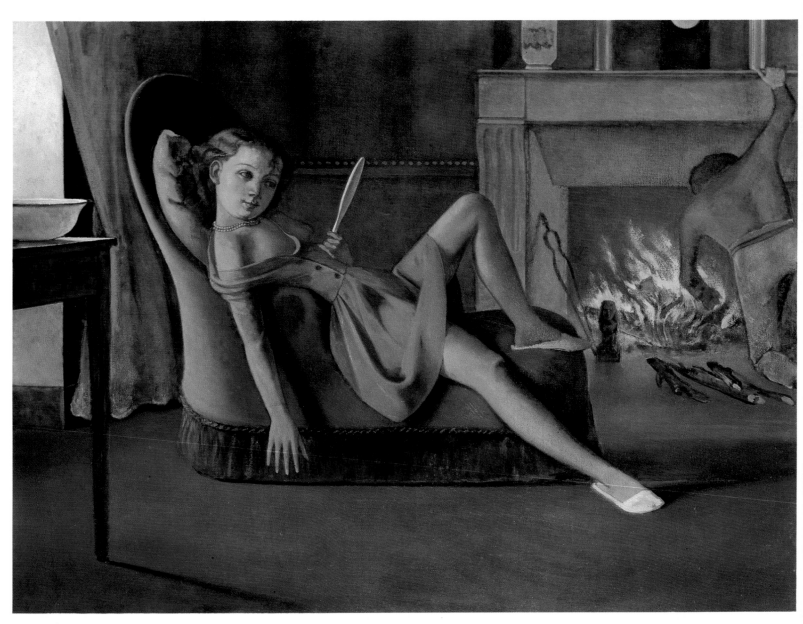

32   *Les beaux jours*   1944–49

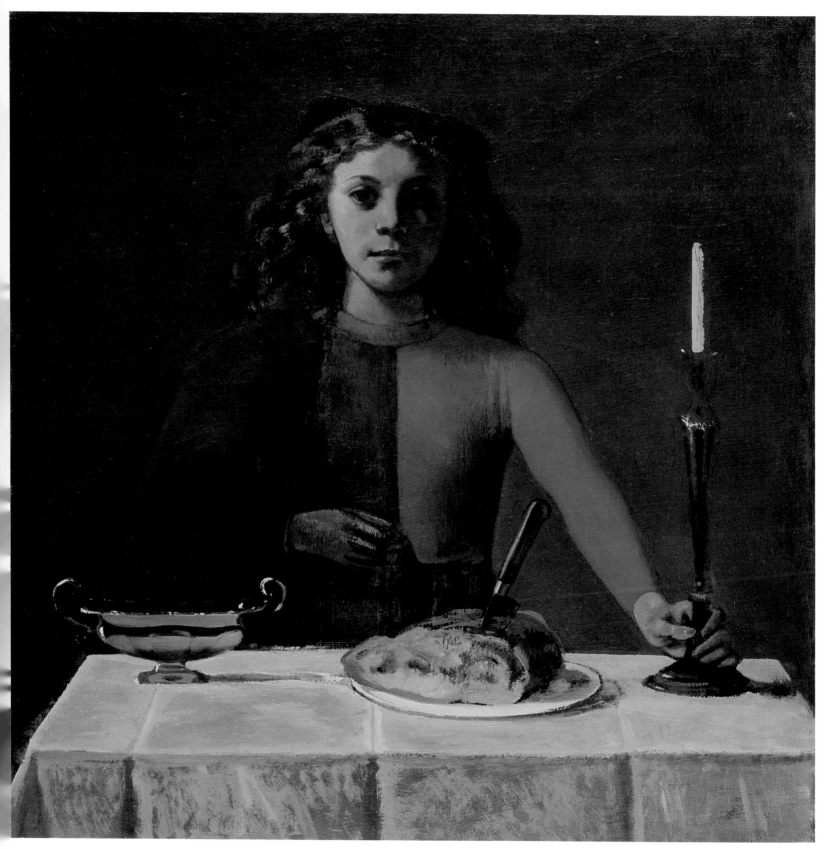

33  *Jeune fille en vert et rouge*  1944

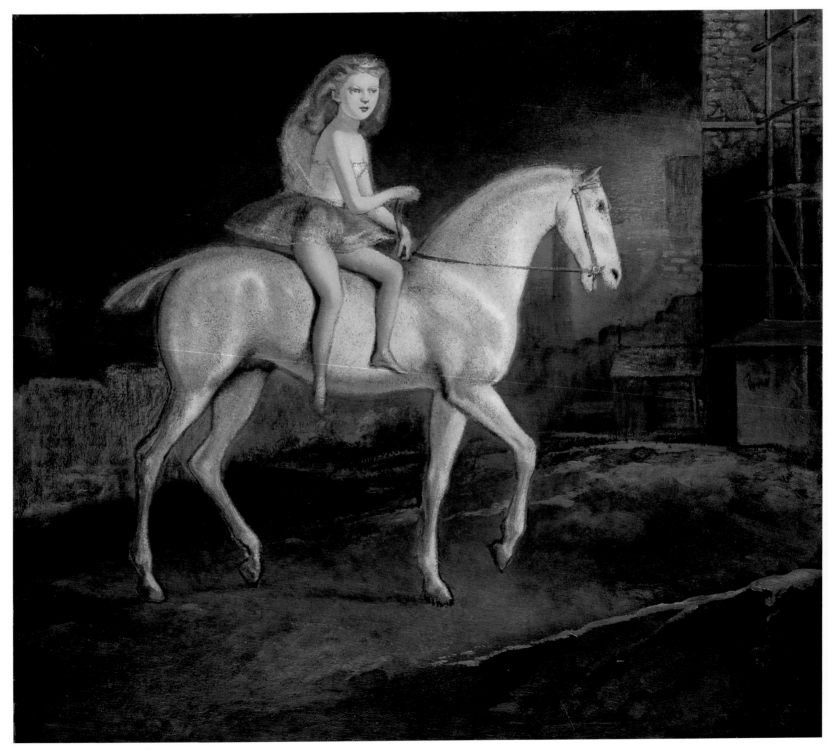

34  *L'écuyère*  1944

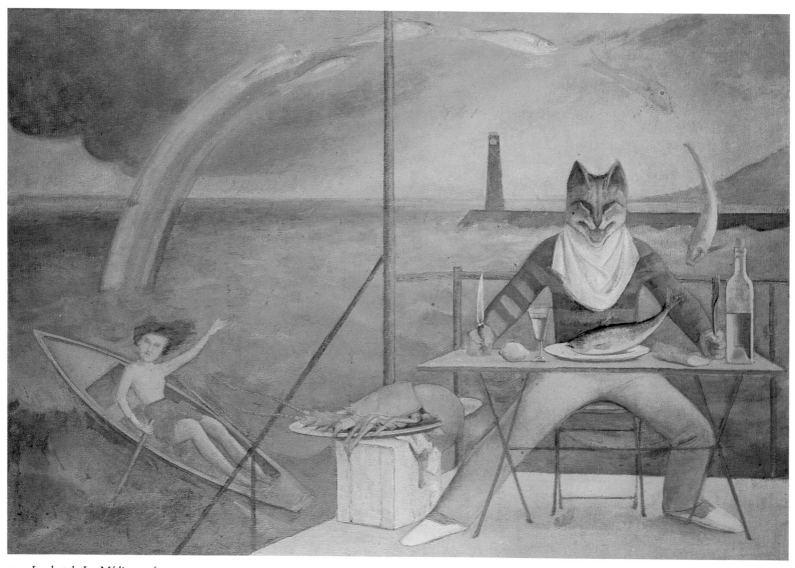

35   *Le chat de La Méditerranée*   1949

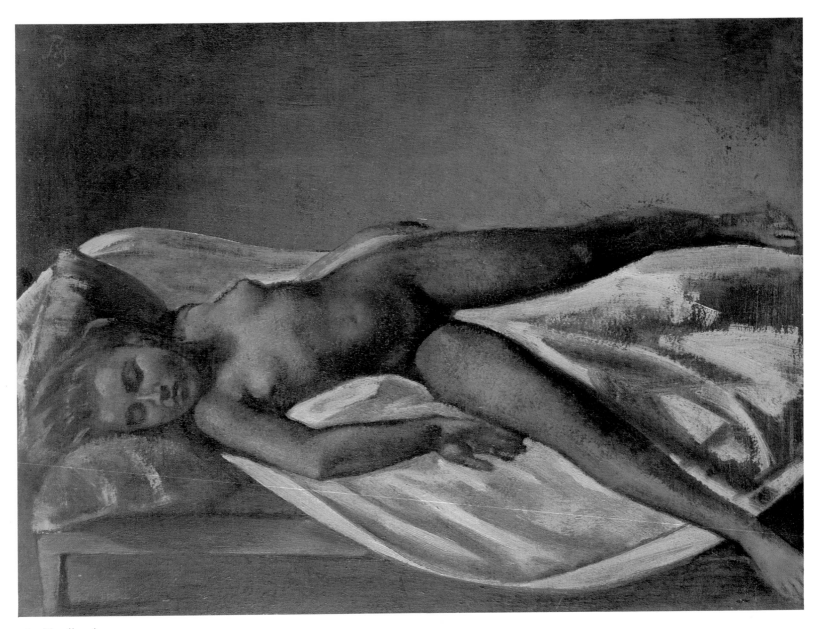

36  *Nu allongé*  1950

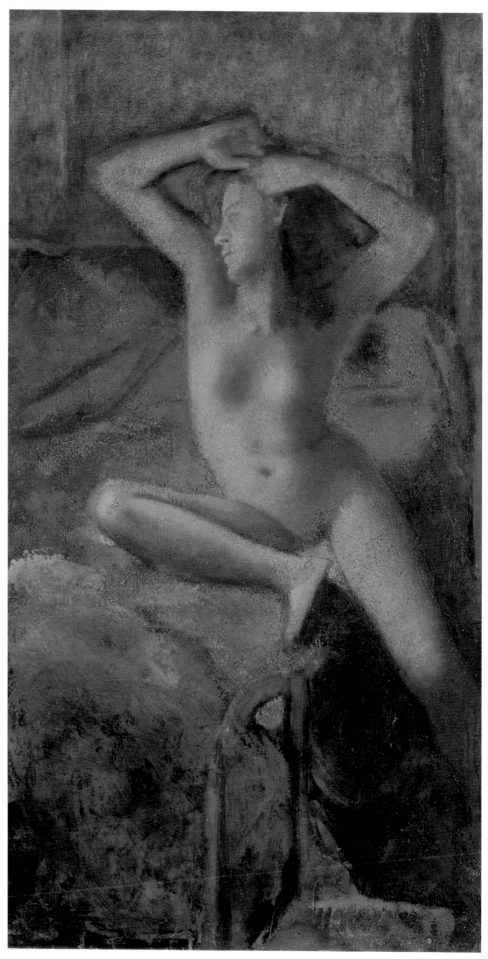

37  *Nu aux bras levés*  1951

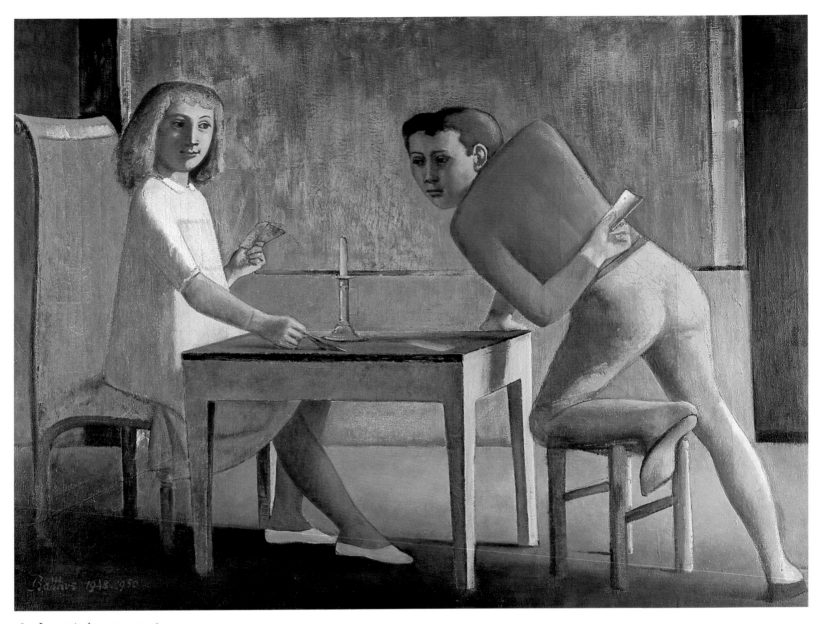

38   *La partie de cartes*   1948–50

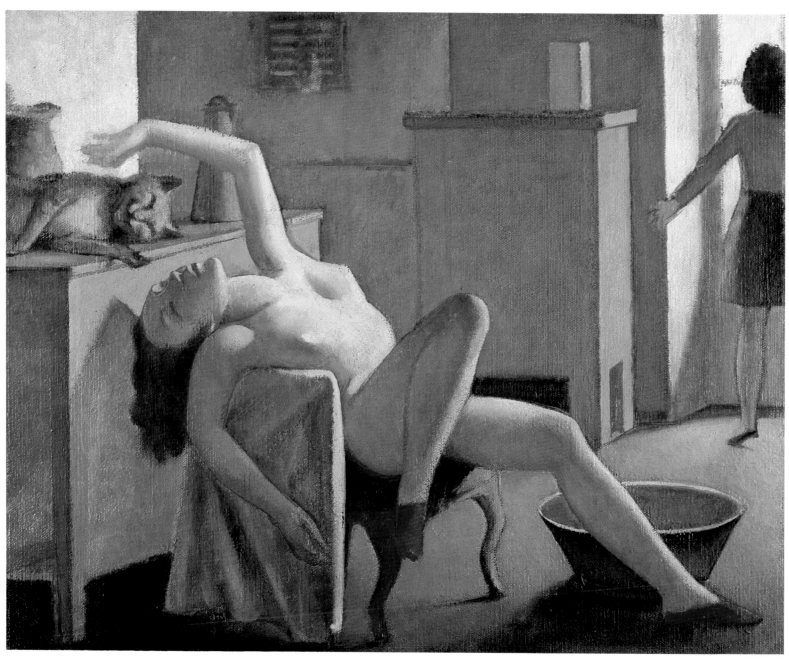

39  *Nu jouant avec un chat*  1949

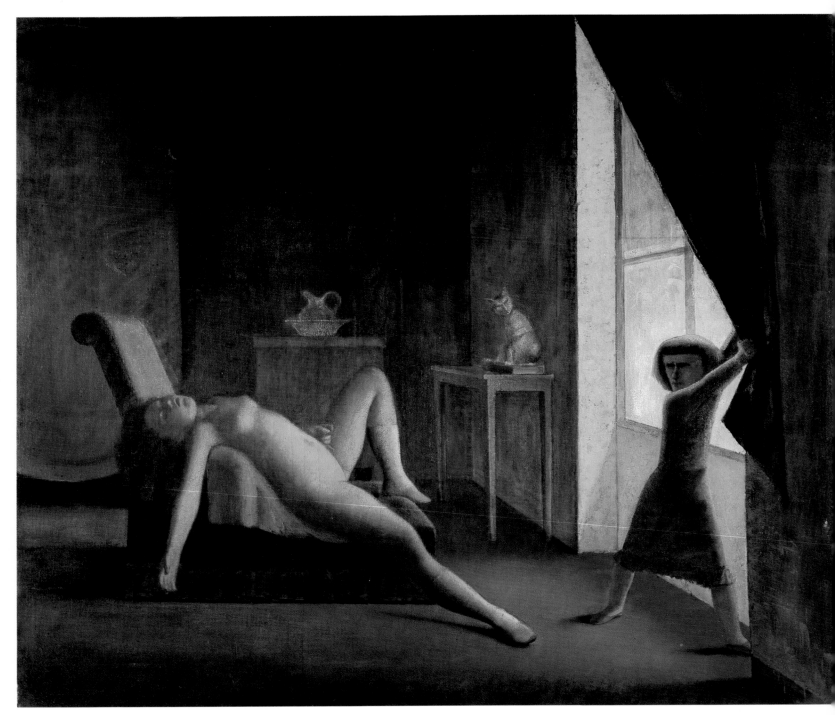

40, 41  *La chambre*  1952–54

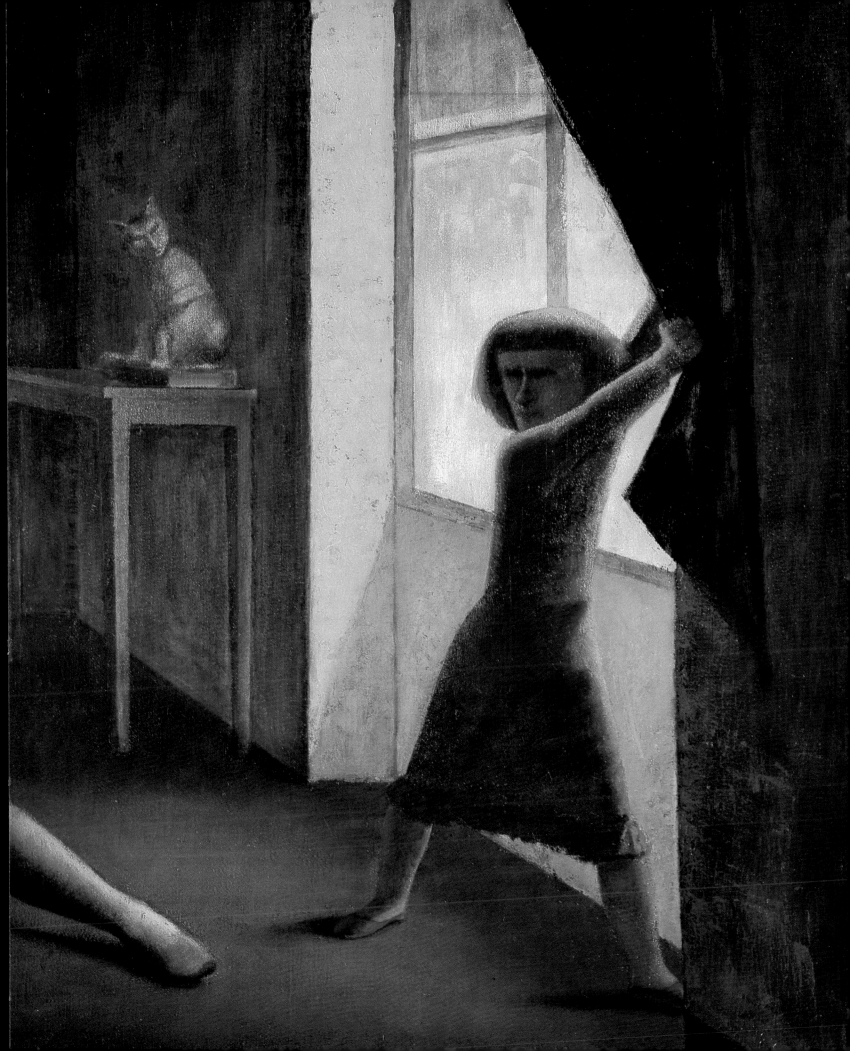

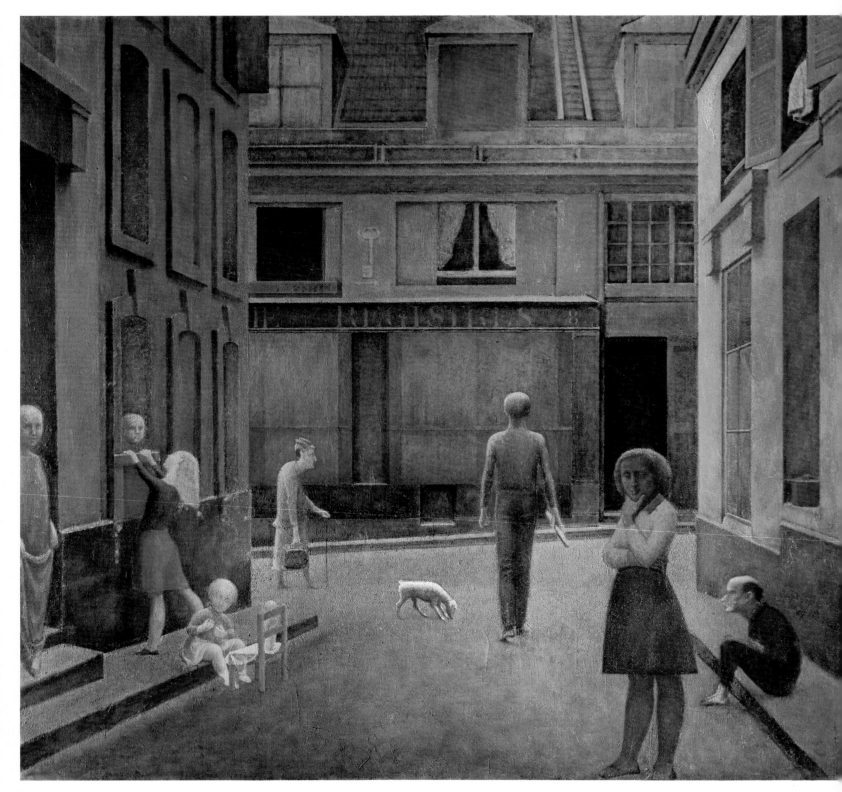

42, 43  *Le passage du Commerce Saint André*  1952–54

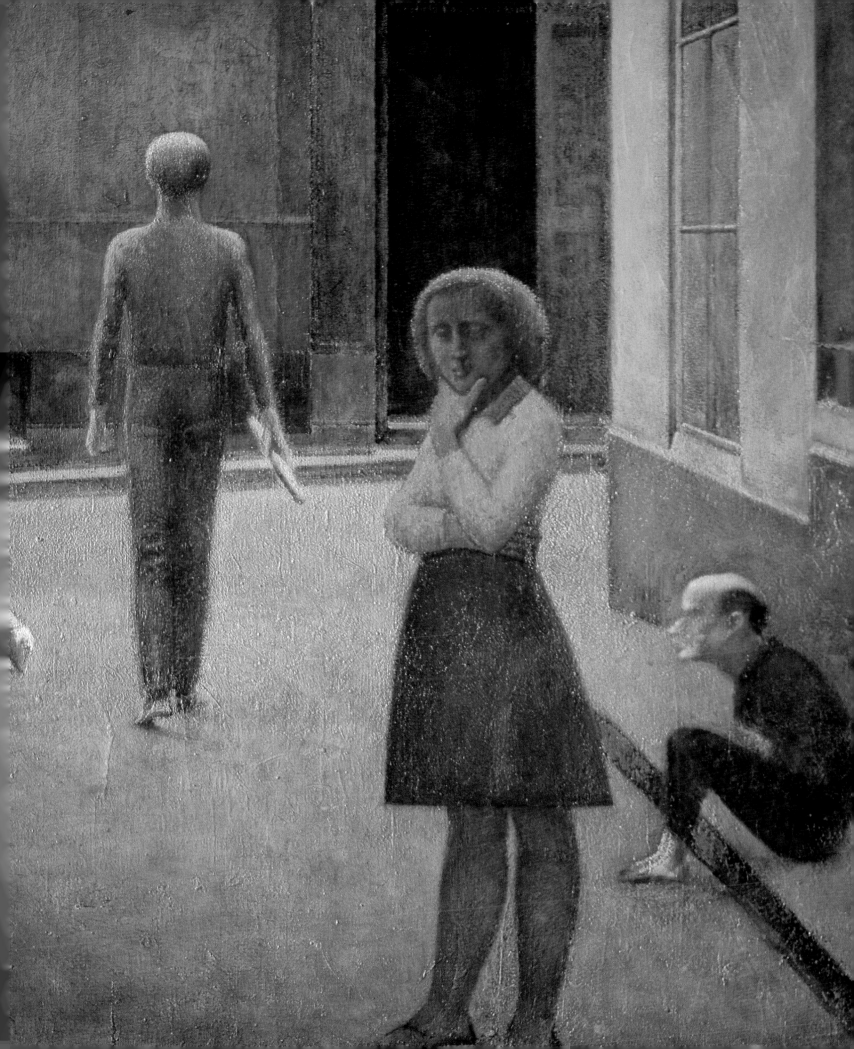

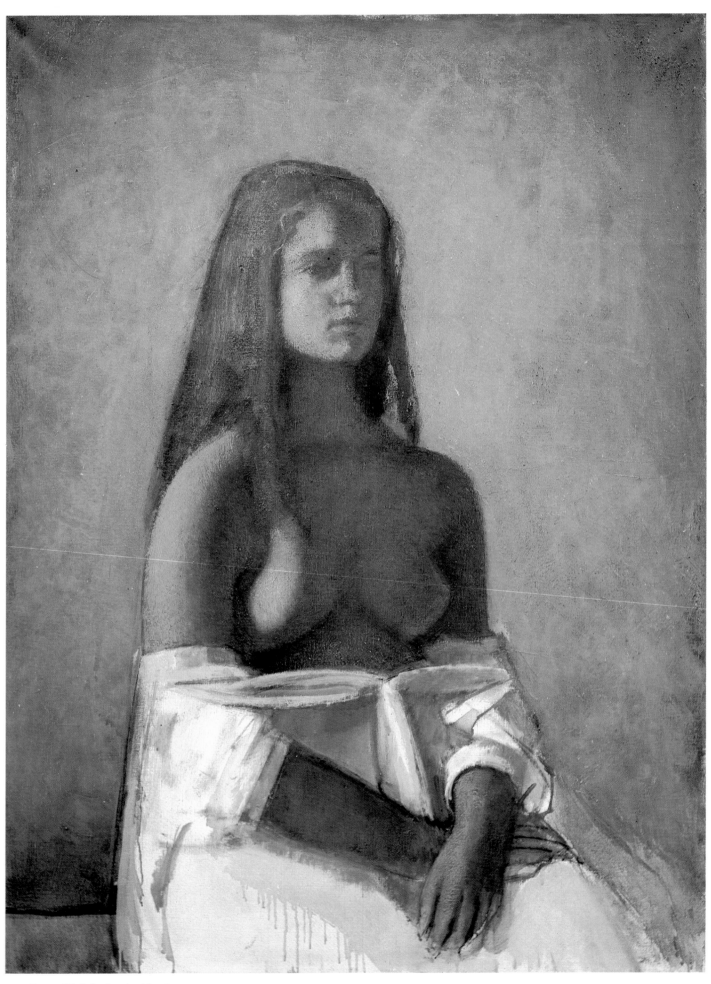

44   *Jeune fille à la chemise blanche*   c.1955

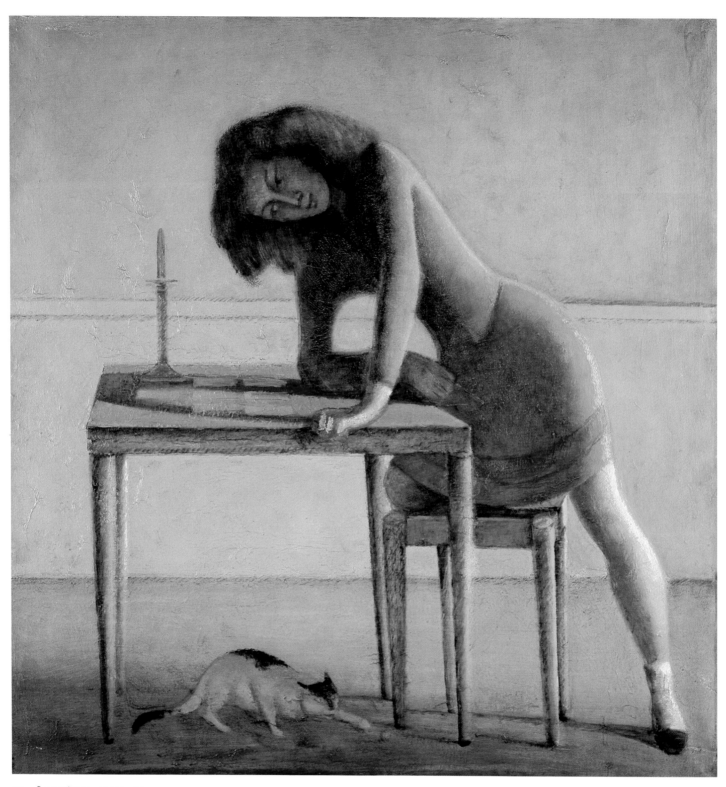

45   *La patience*   1954–55

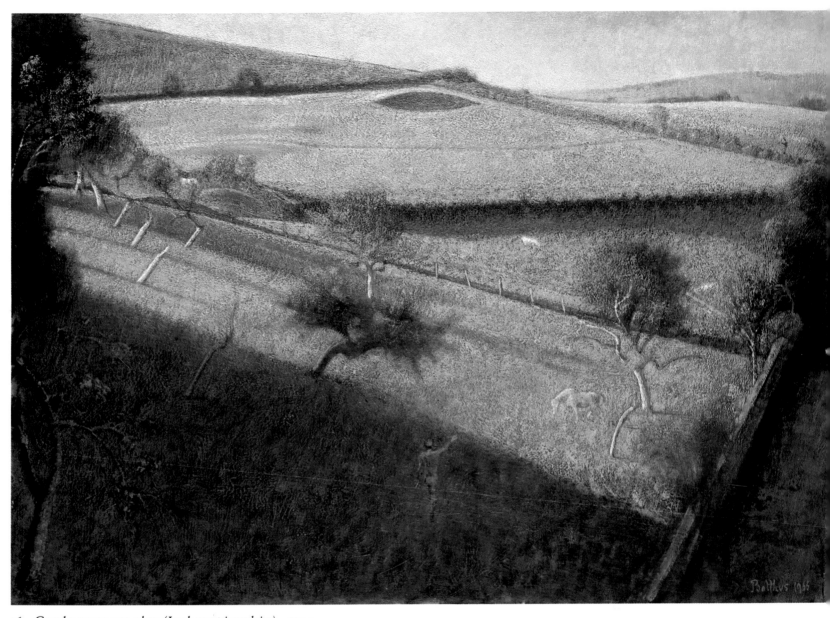

46   *Grand paysage aux arbres (Le champ triangulaire)*   1955

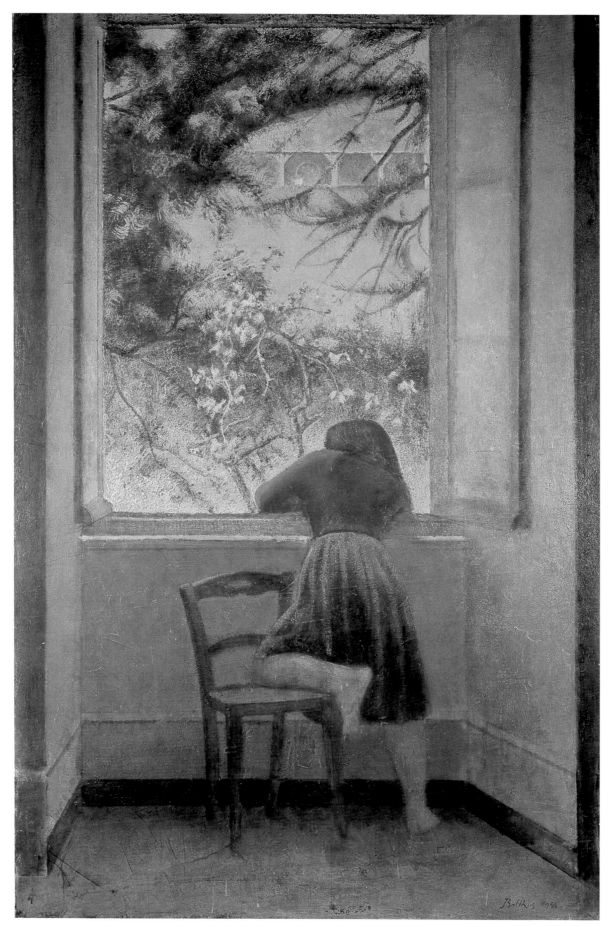

47  *Jeune fille à la fenêtre*  1955

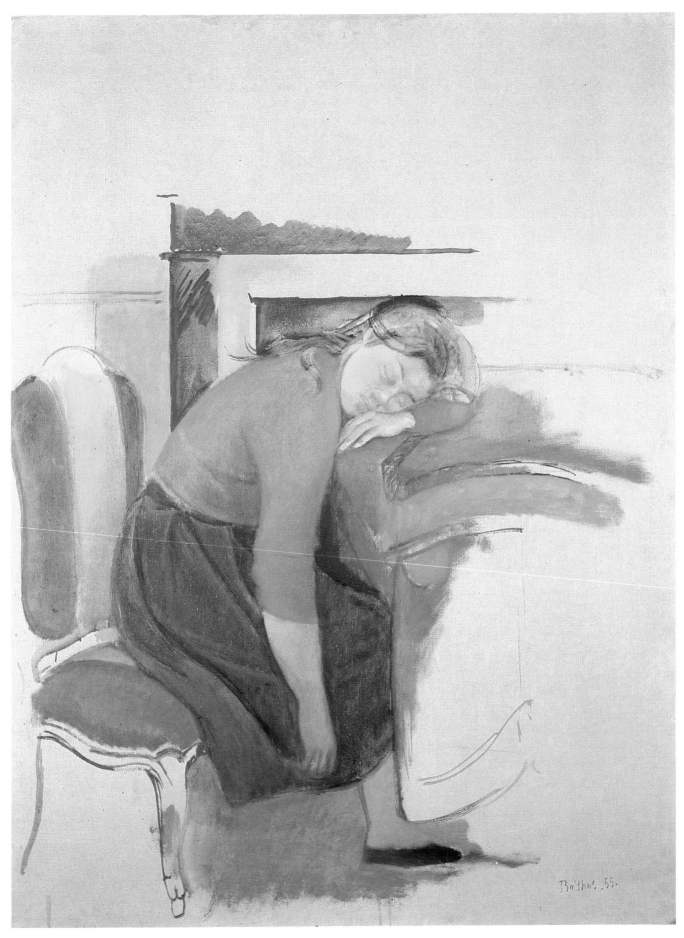

48  *Jeune fille endormie*  1955

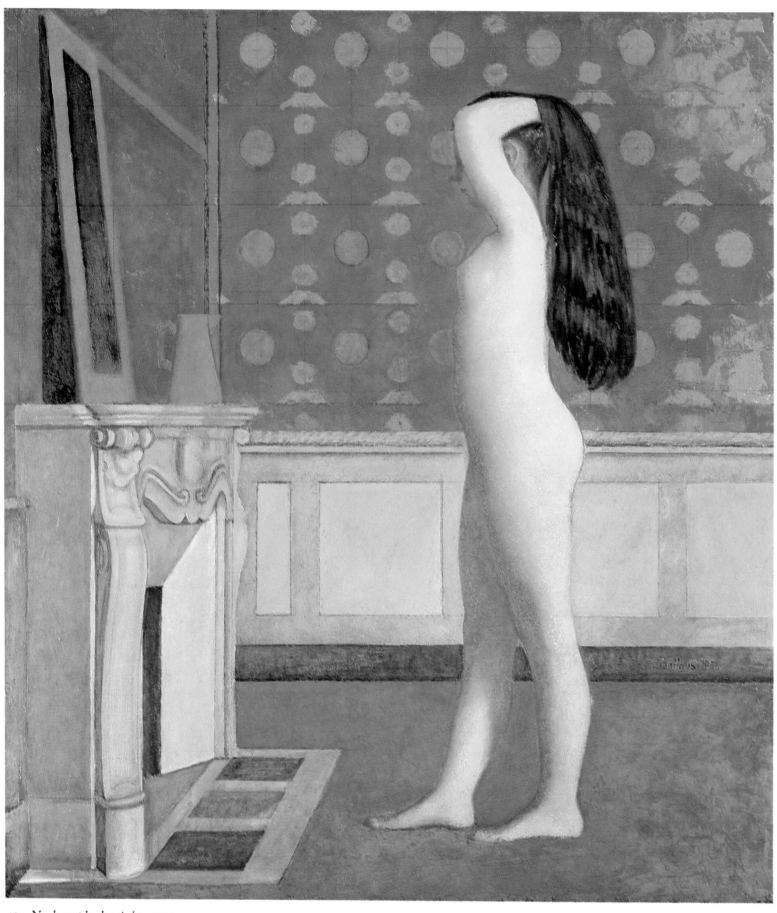

49 *Nu devant la cheminée* 1955

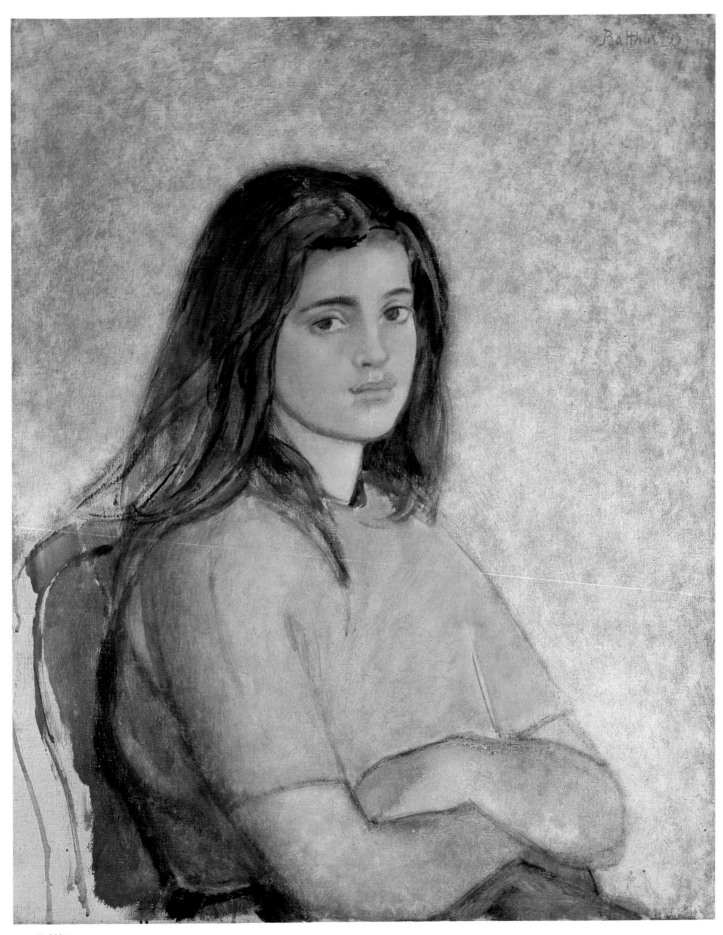

50 *Frédérique* 1955

51  *Nature morte*  c.1956

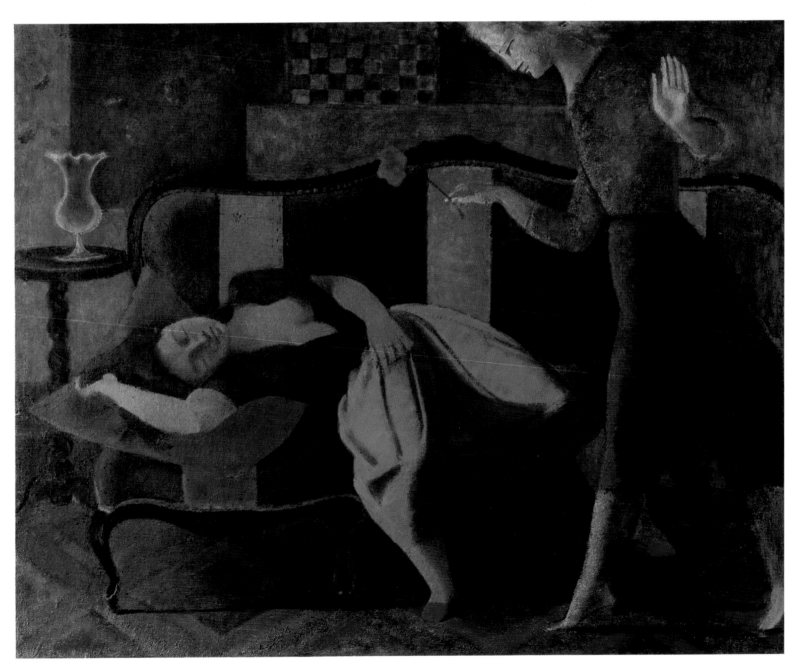

52  *Le rêve I*  1955–56

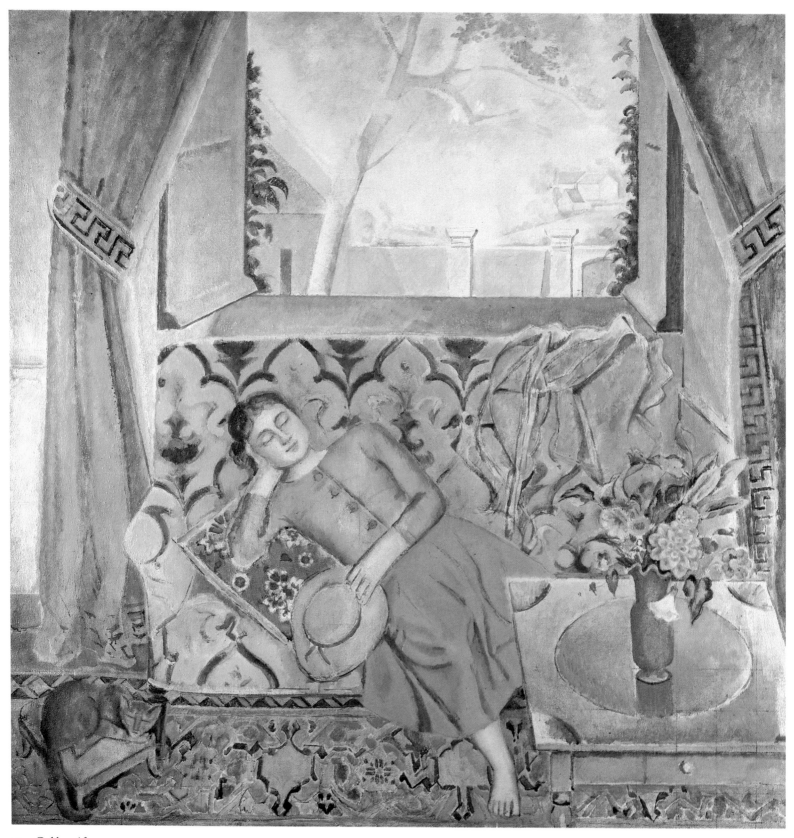

53  *Golden Afternoon*  1957

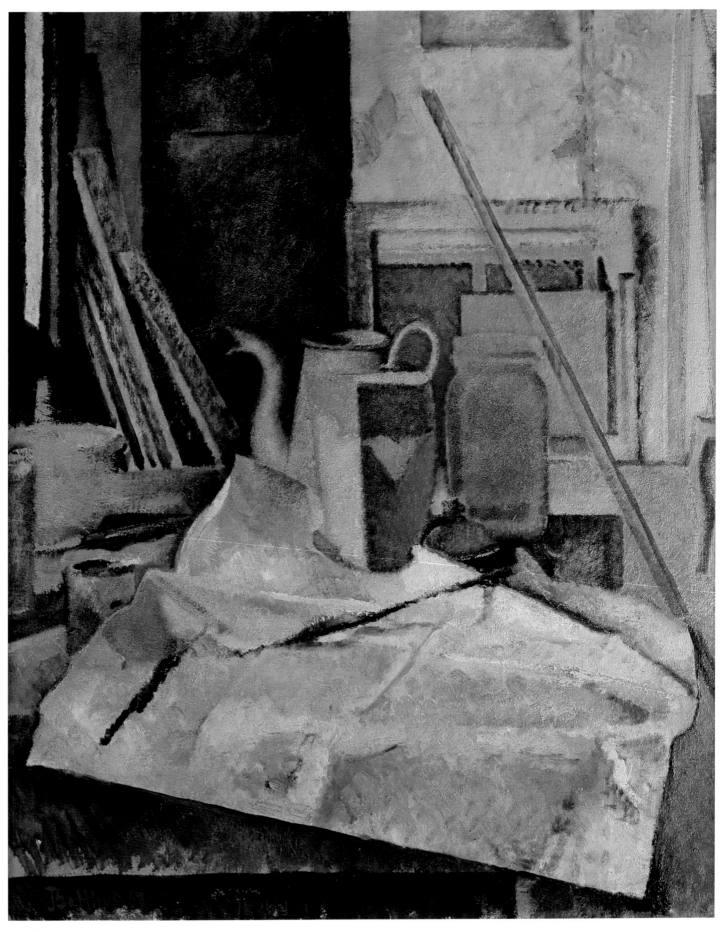

54 *Nature morte* 1958

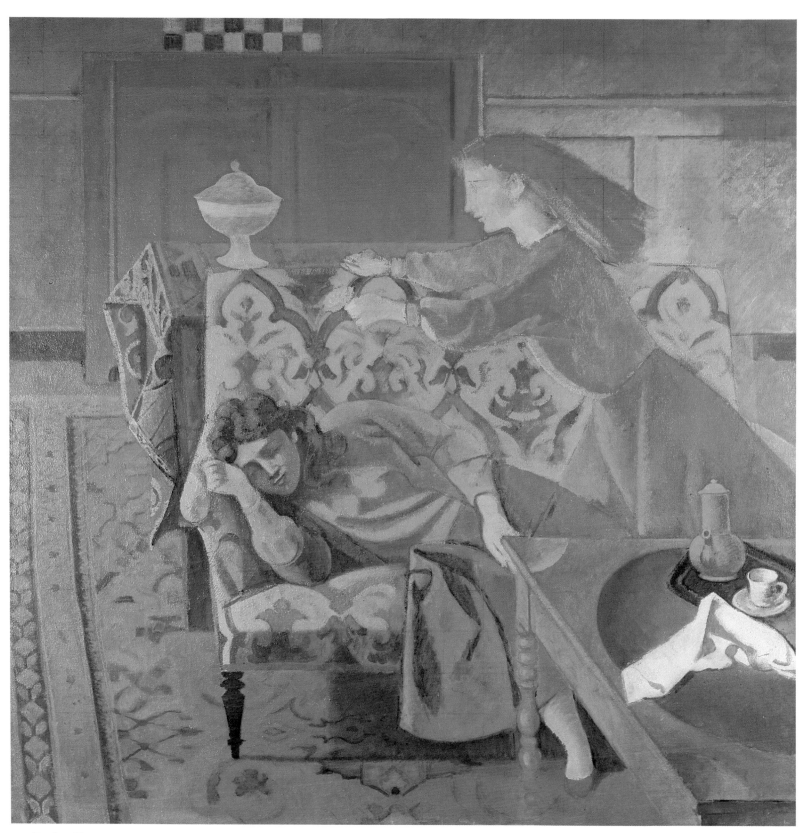

55 *Le rêve II* 1956–57

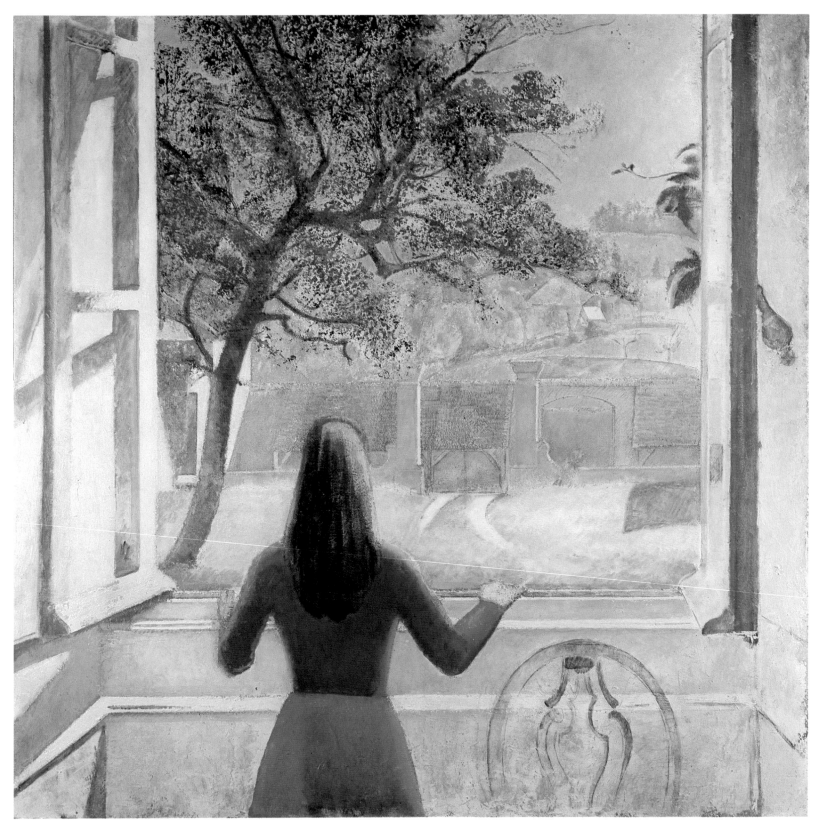

56   *Jeune fille à la fenêtre*   1957

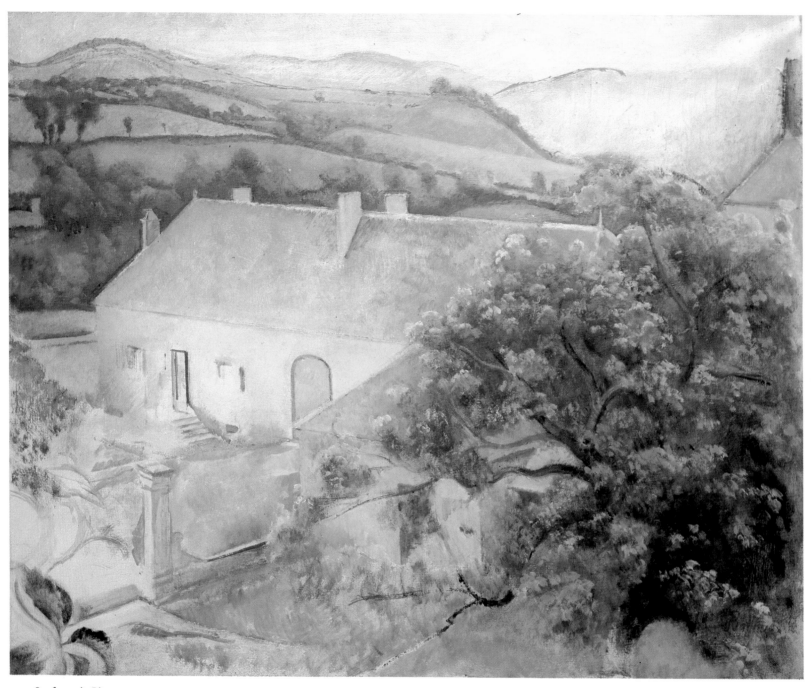

57   *La ferme à Chassy*   1958

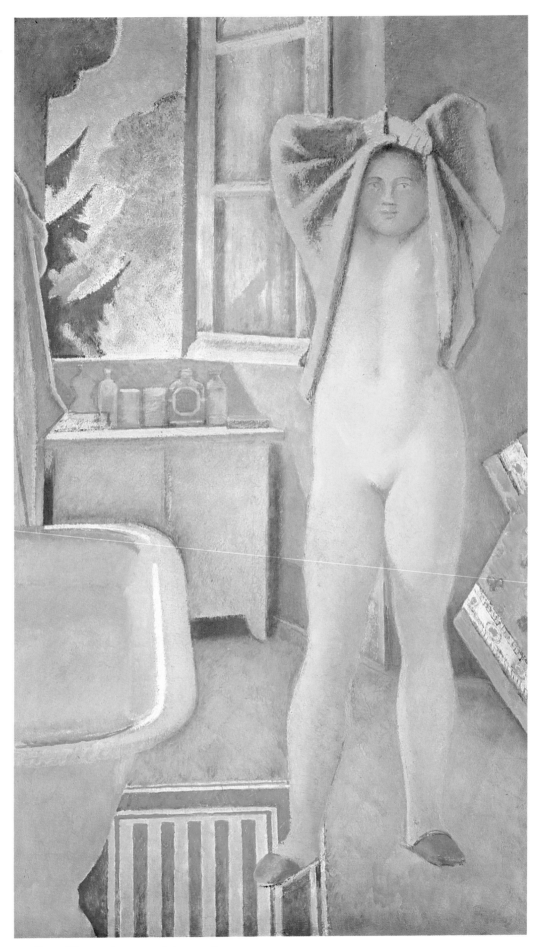

58   *Jeune fille se préparant au bain*   1958

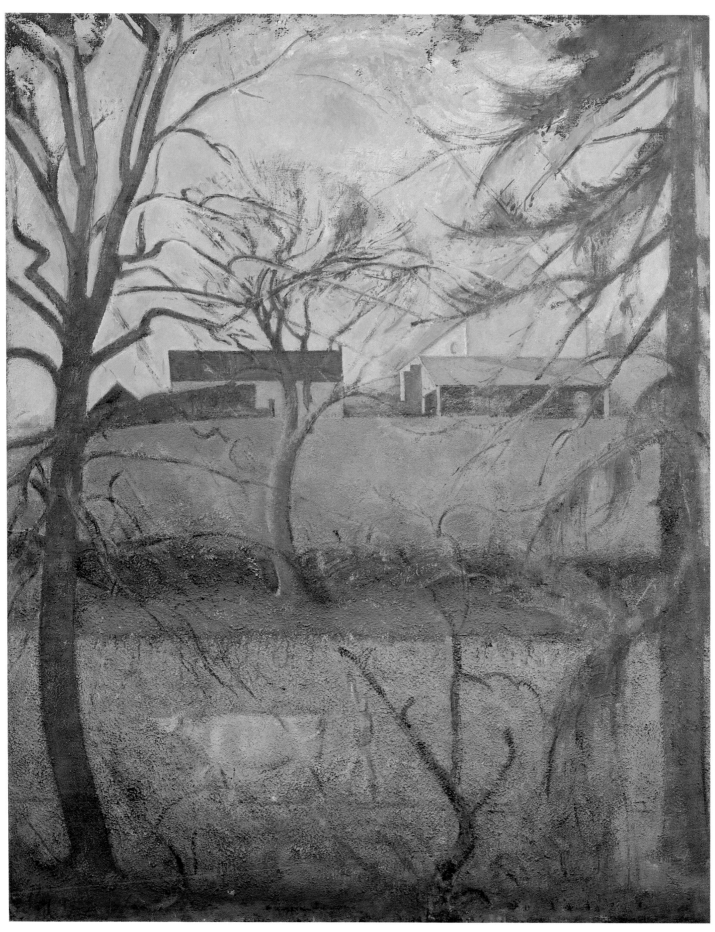

59  *Grand paysage avec vache*  1959–60

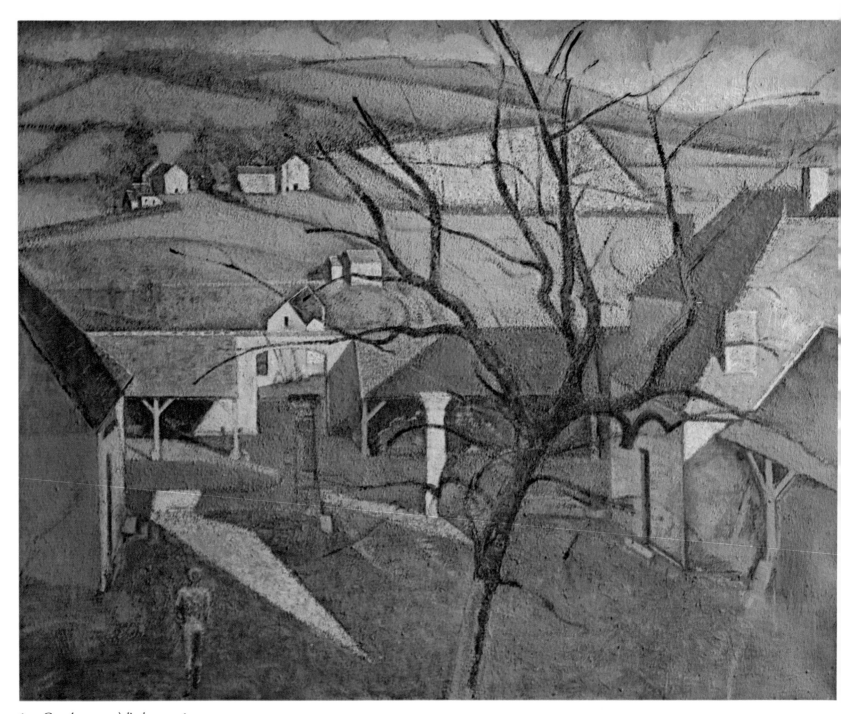

60   *Grand paysage à l'arbre*   1960

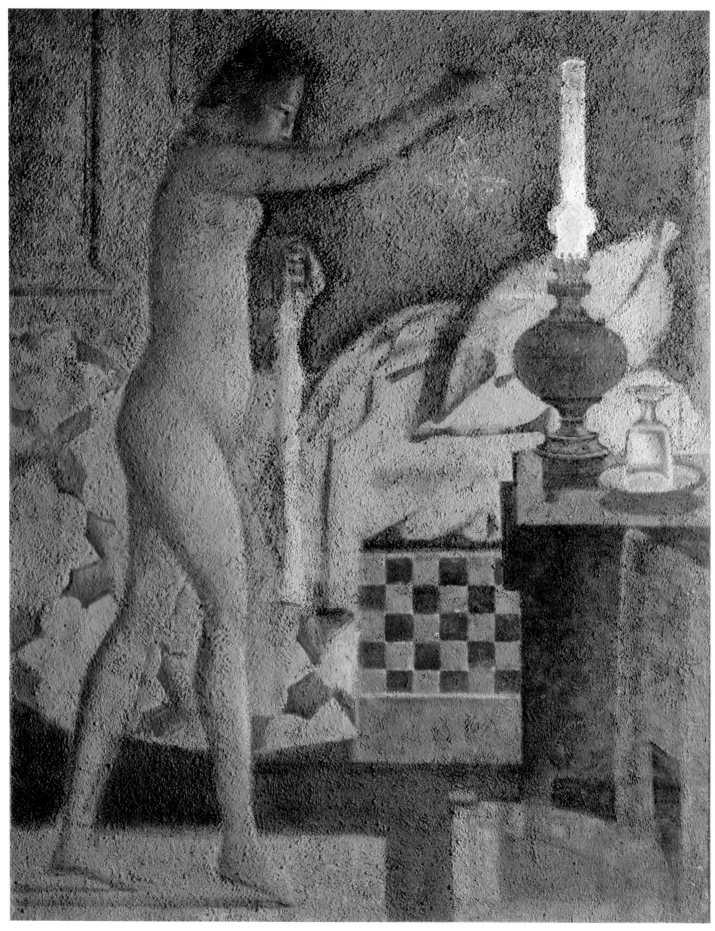

61  *Le phalène*  1959

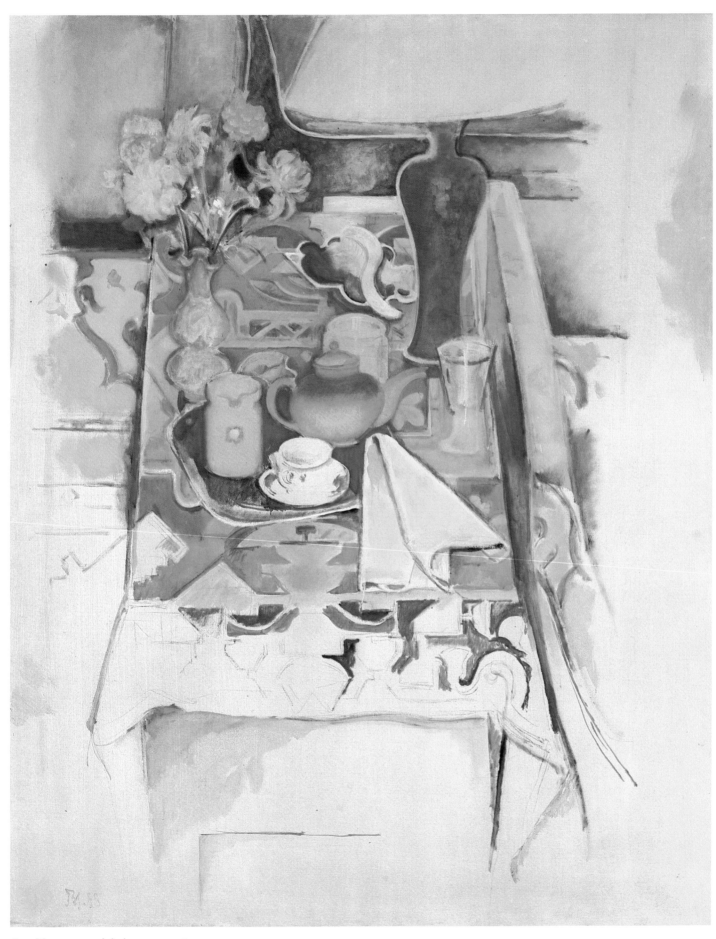

62   *Nature morte à la lampe*   *1958*

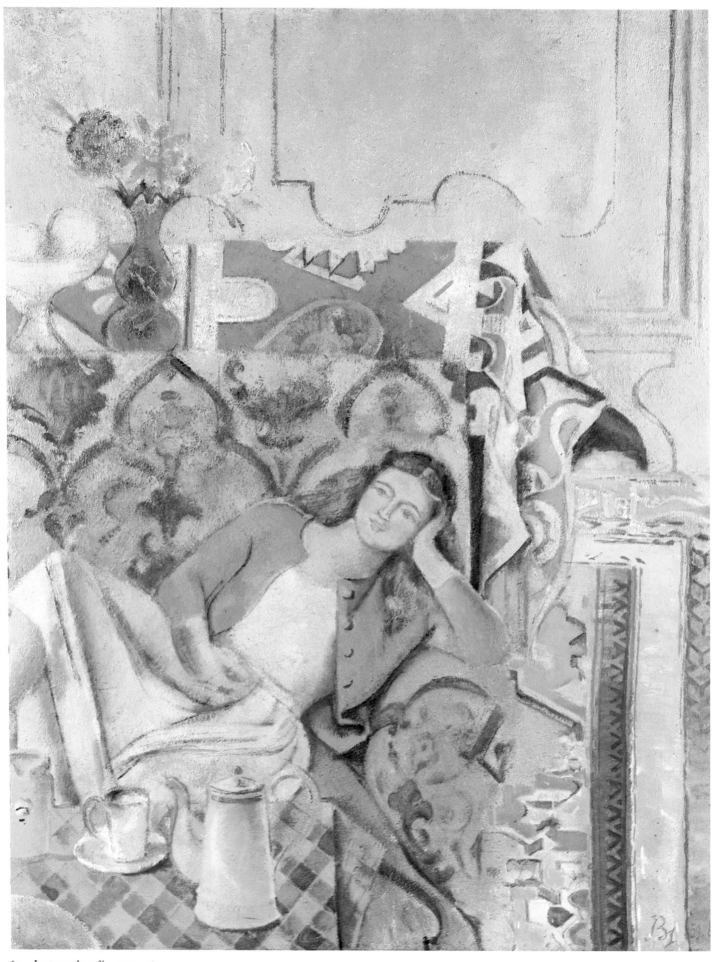

63  *La tasse de café*  1959–60

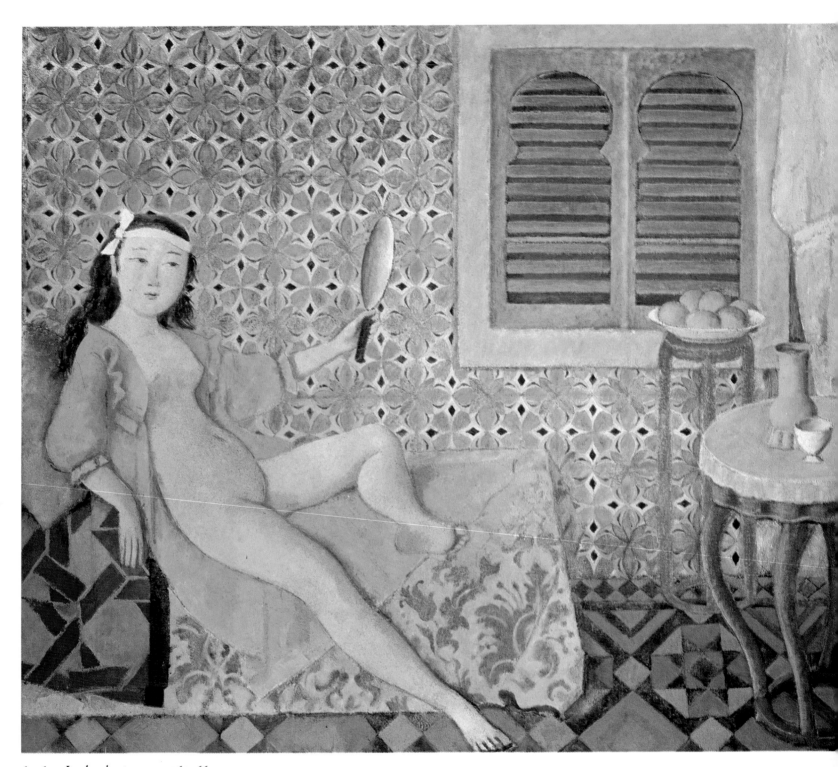

64, 65   *La chambre turque*   1963–66

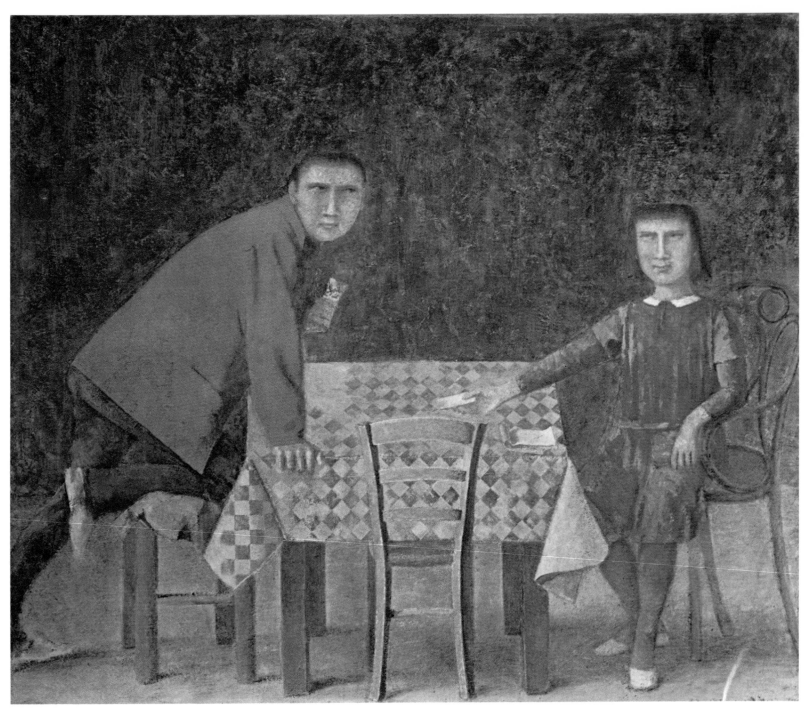

66  *Les joueurs de cartes*  1968–73

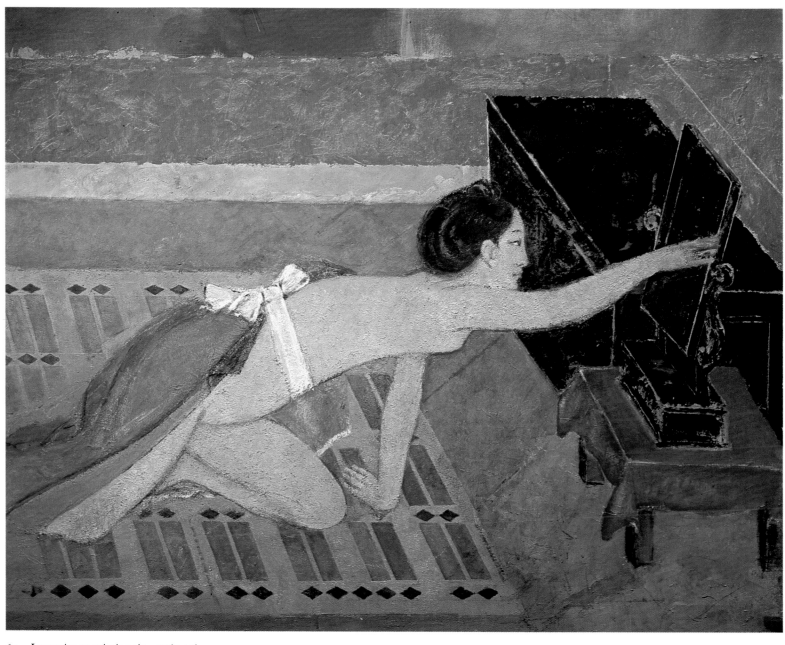

67 *Japonaise au miroir noir* 1967–76

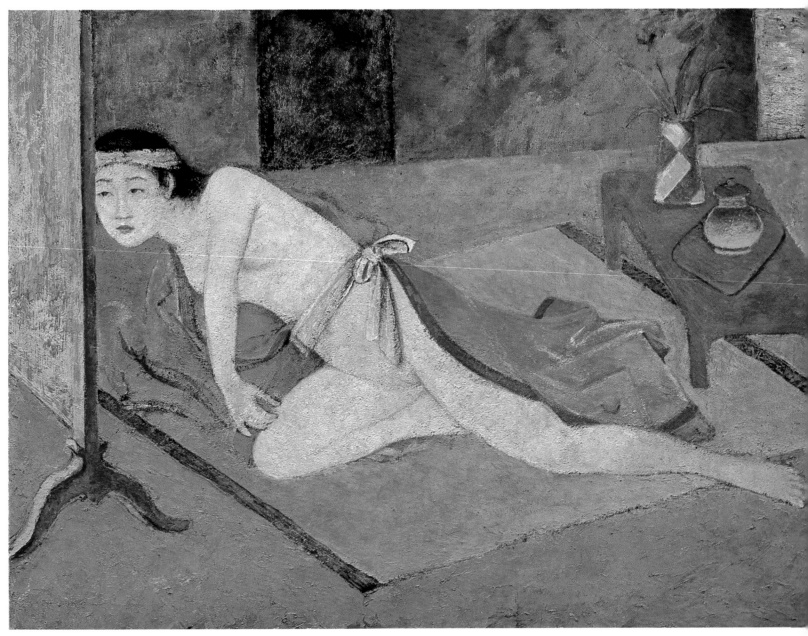

68, 69   *Japonaise à la table rouge*   1967–76

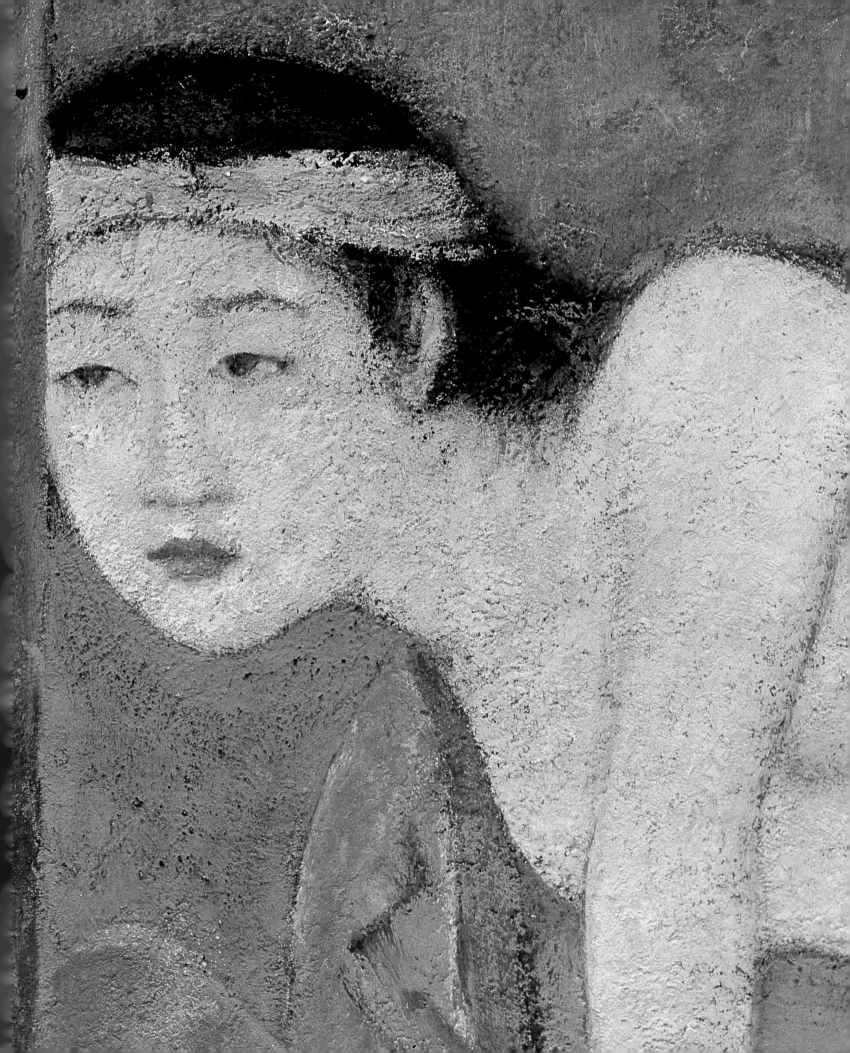

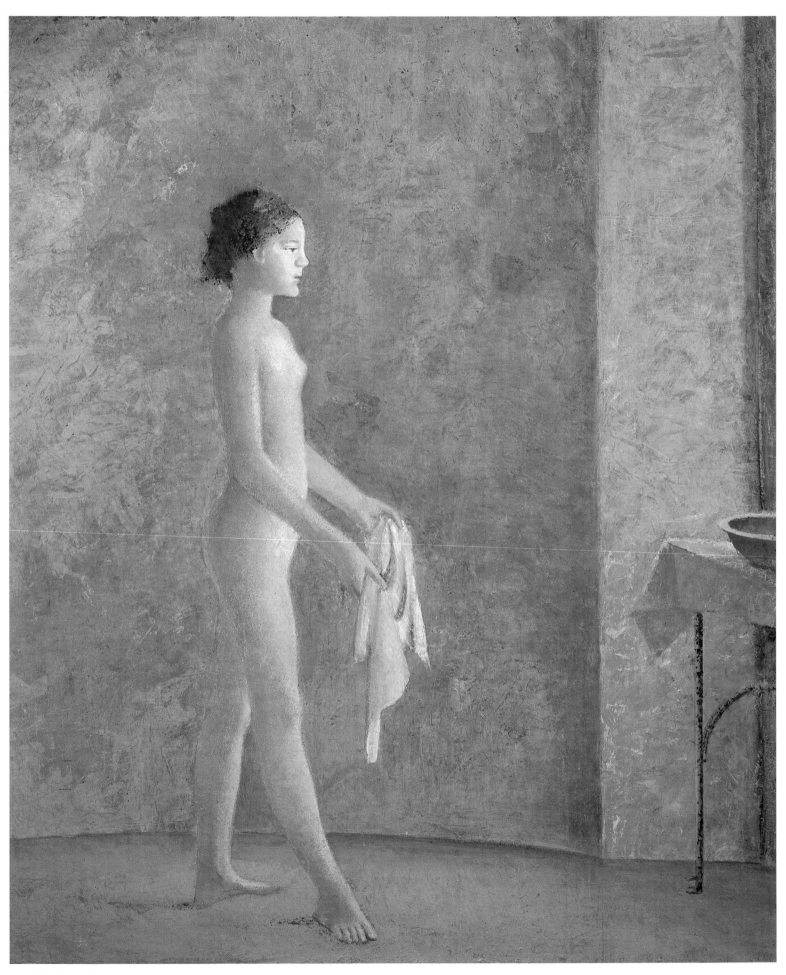

70  *Nu de profil*  1973–77

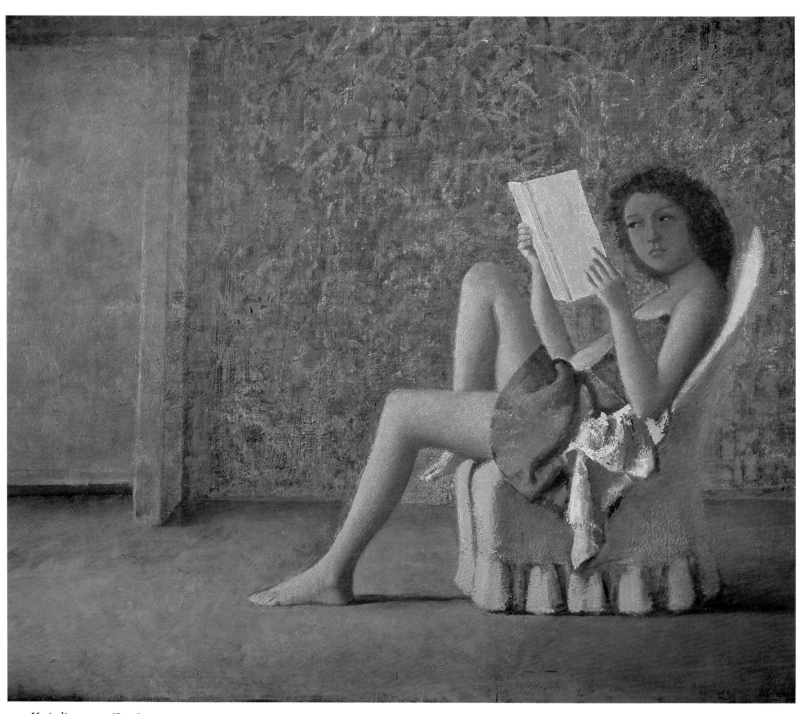

71  *Katia lisant*  1968–76

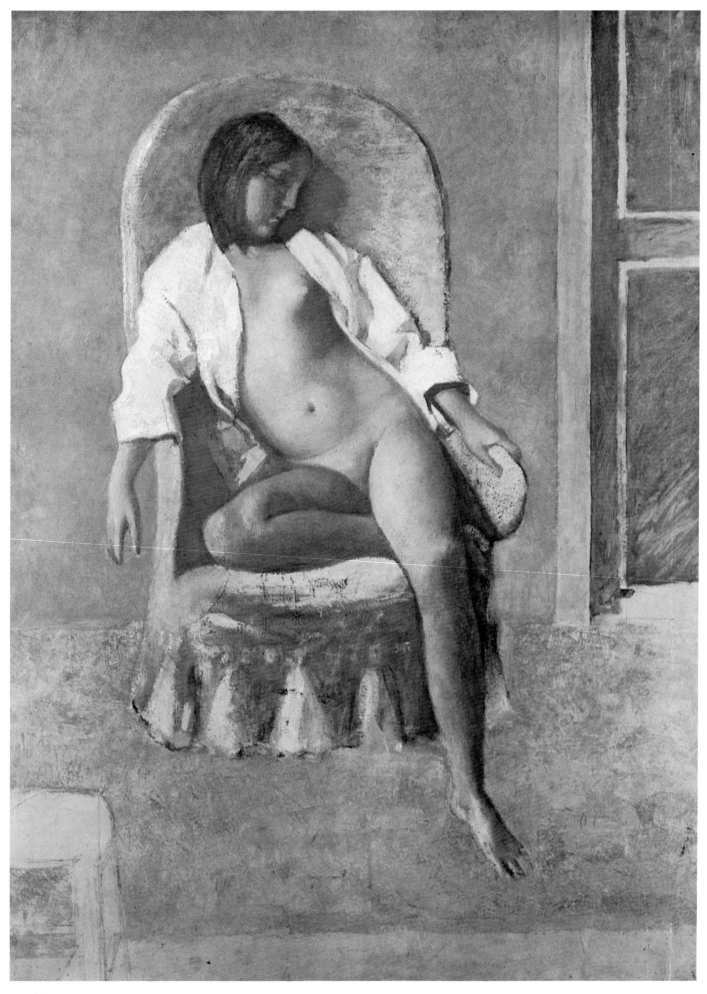

72   *Nu au repos*   1977

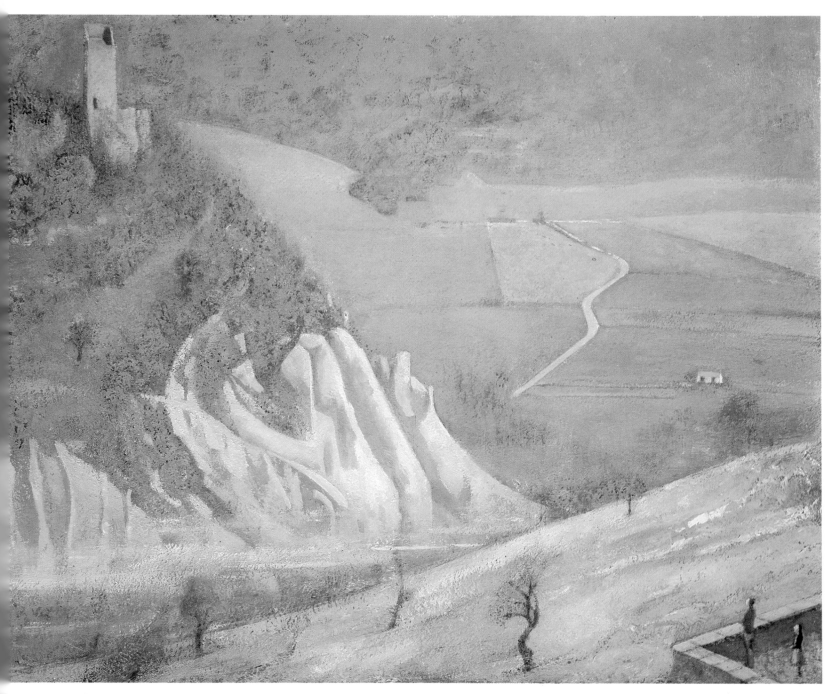

73  *Monte Calvello*  1977–79

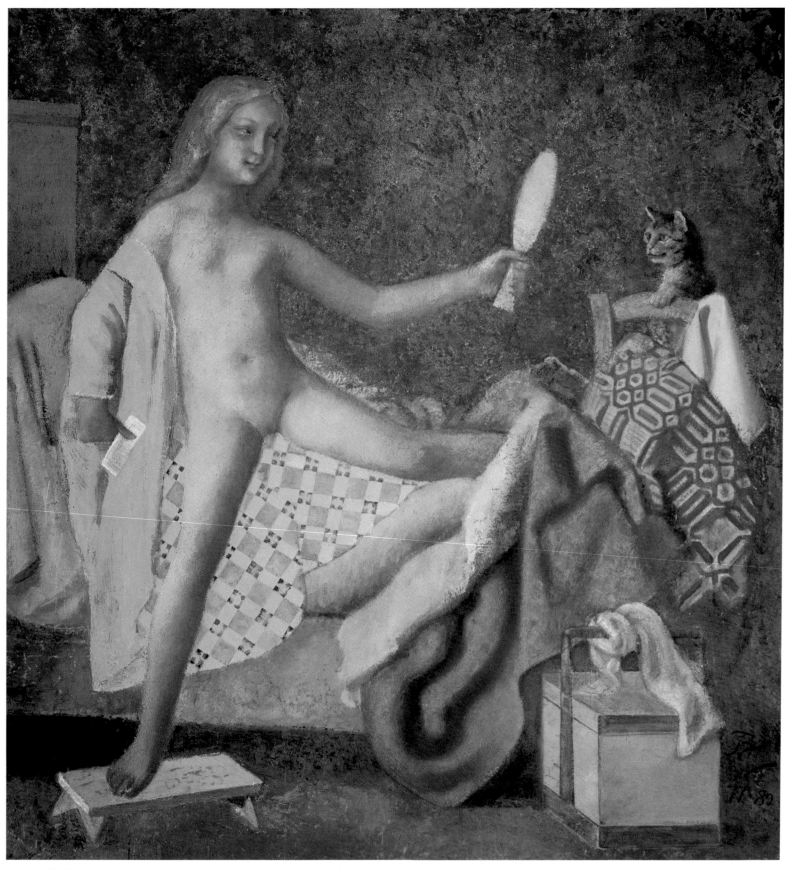

74, 75   *Le chat au miroir*   1977–80

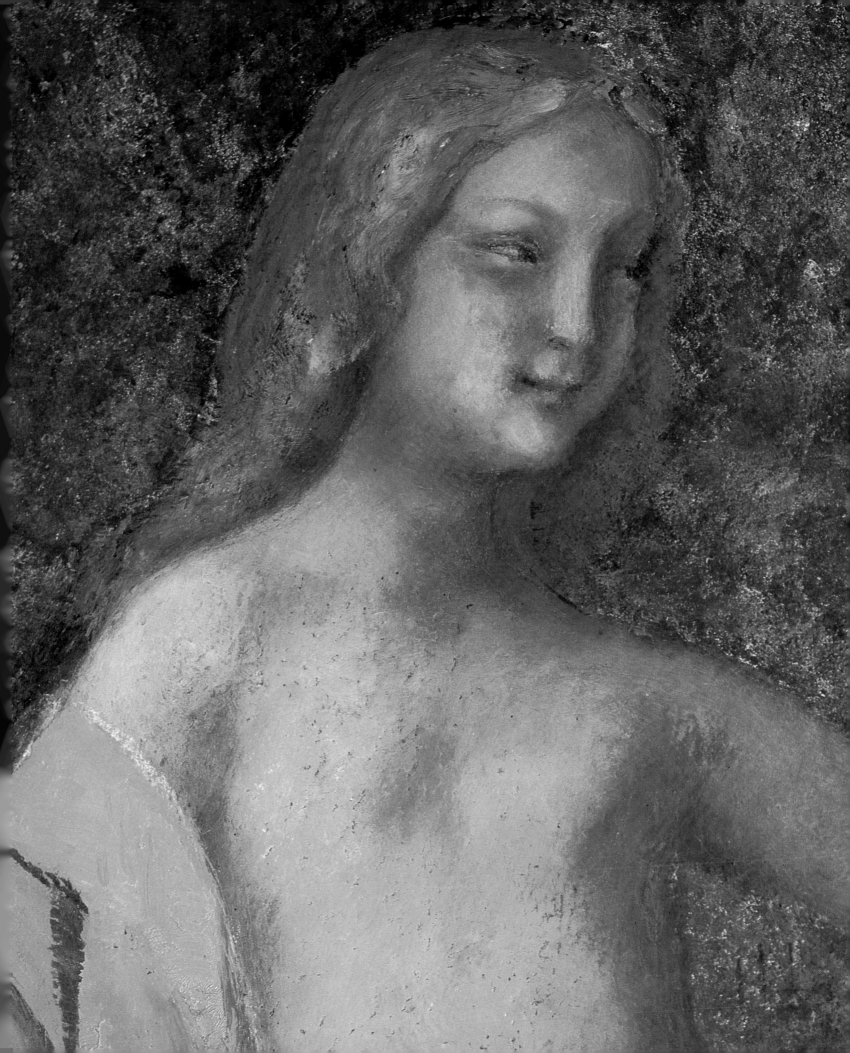

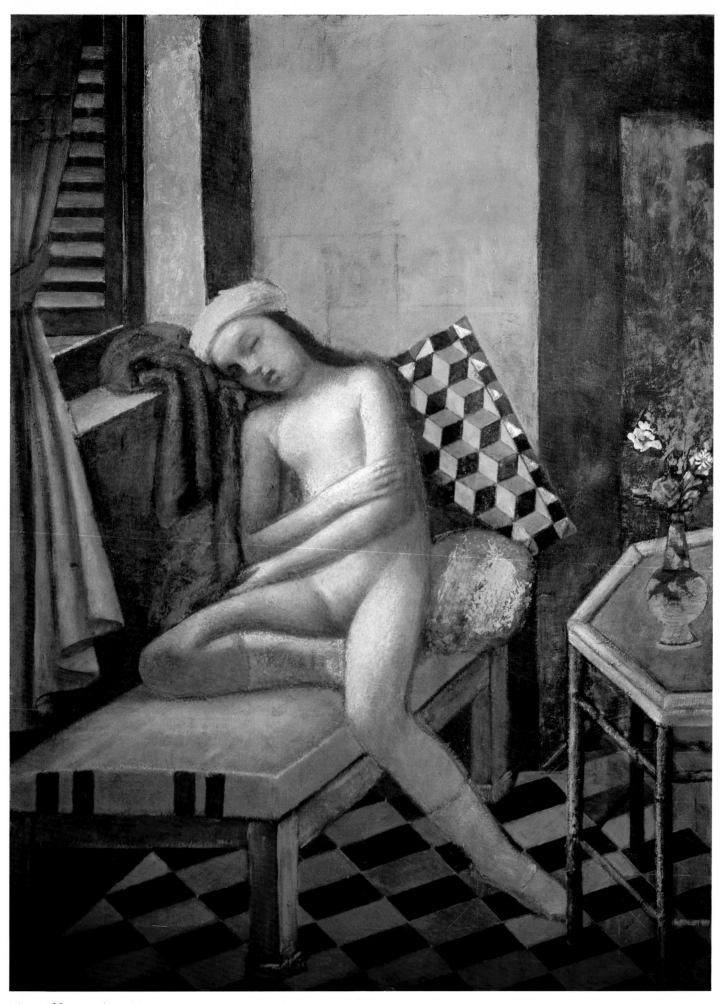

76, 77  *Nu assoupi*  1980

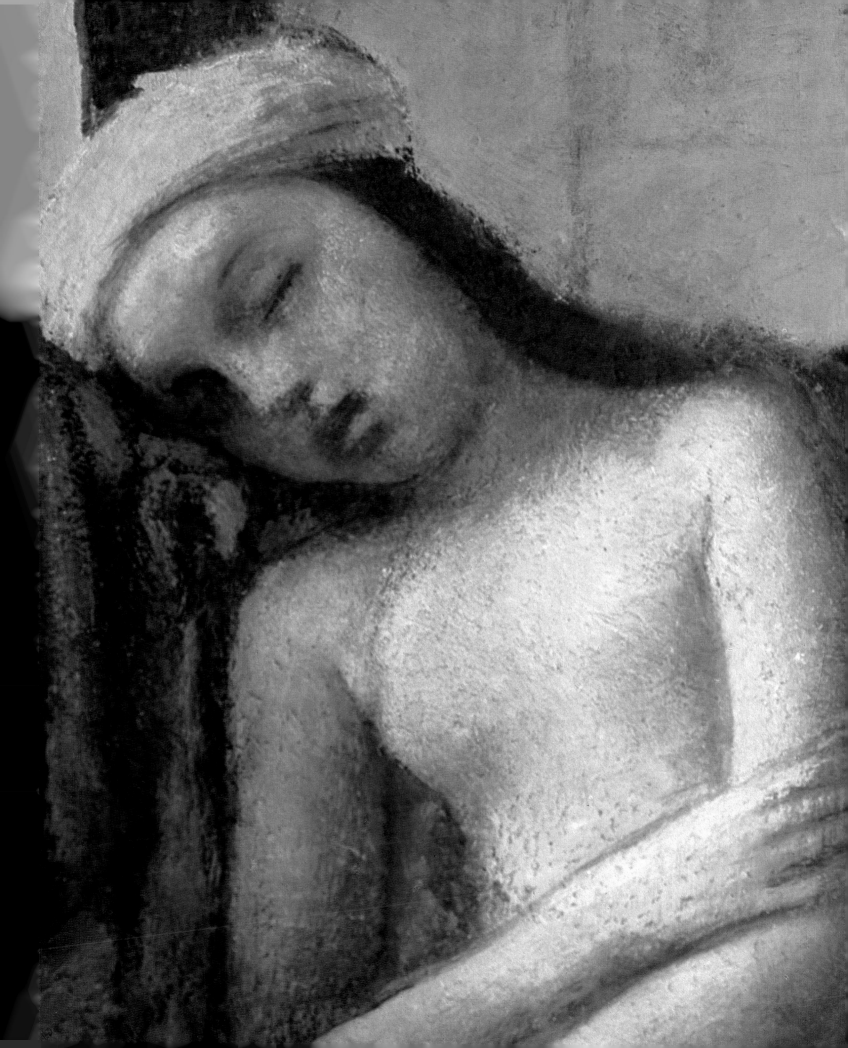

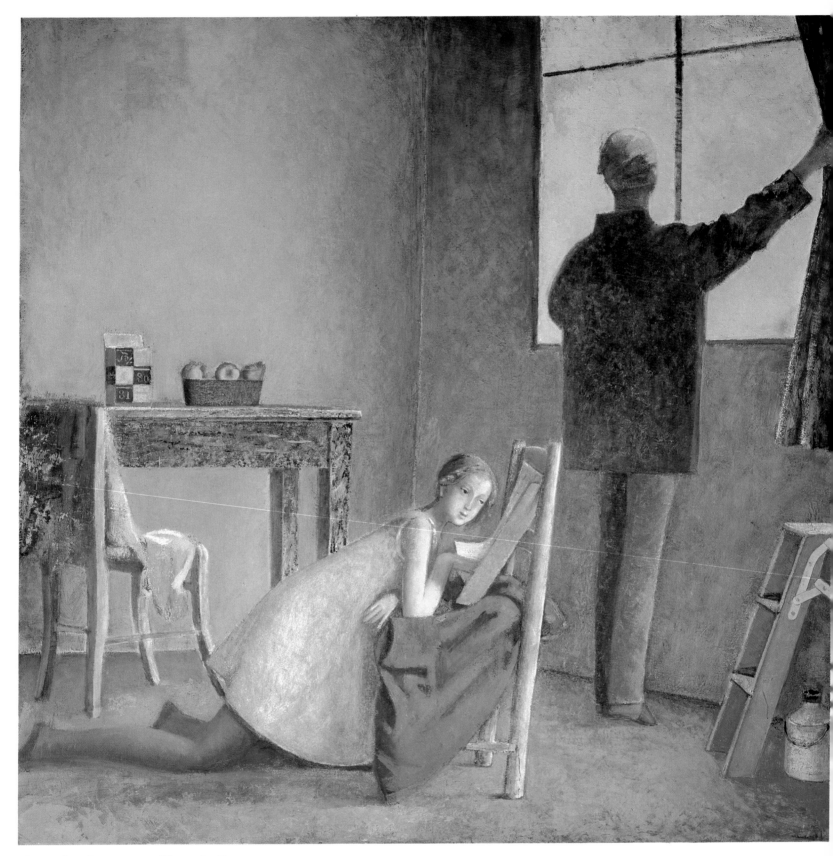

78, 79  *Le peintre et son modèle*  1980–81

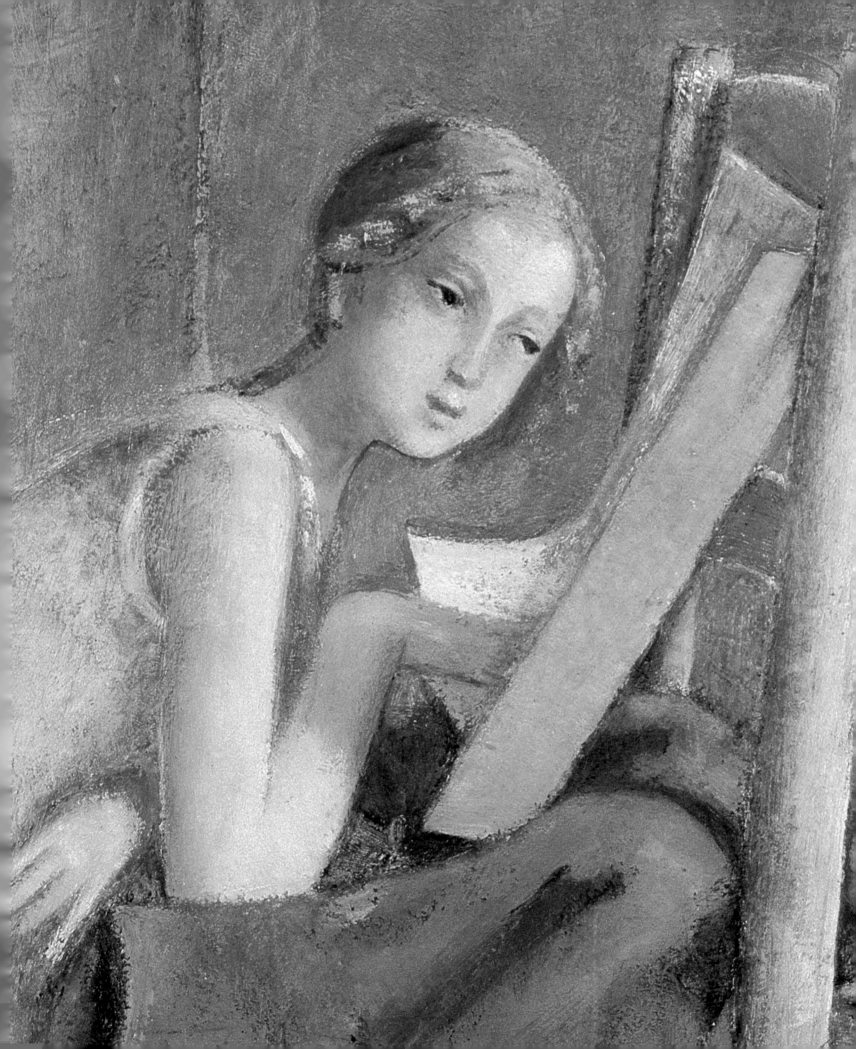

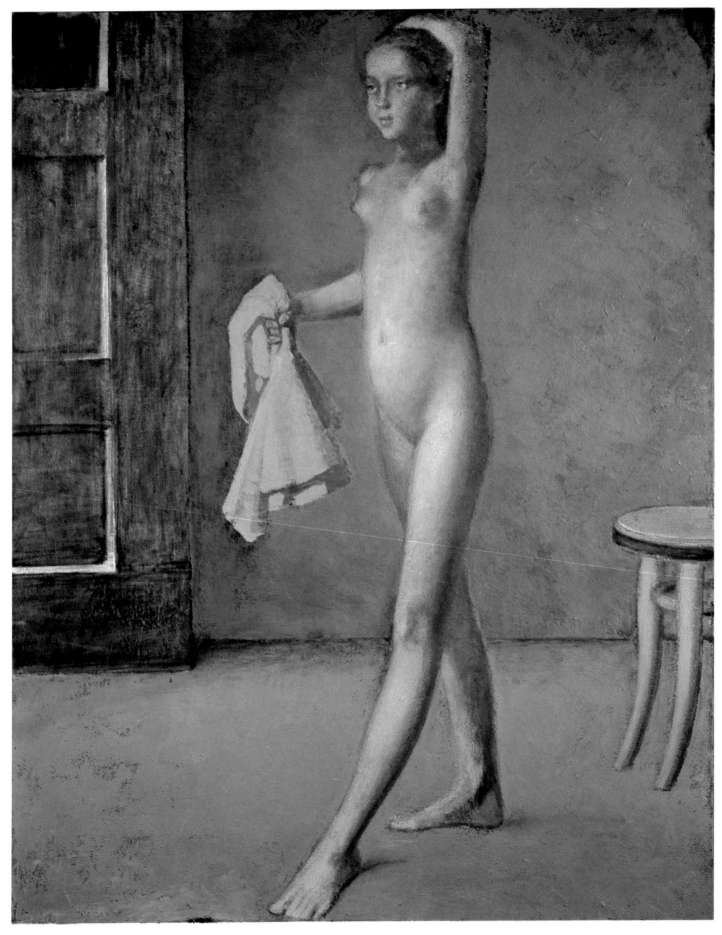

80  1981–82

# List of illustrations

*Measurements are given in centimetres and inches, height before width.*

1 *Café de l'Odéon*
1928
Oil on canvas
100 × 79 (39$\frac{3}{8}$ × 31)
Private collection
Photo Jacqueline Hyde

2 *Le Pont Neuf*
*c*.1927
Oil on canvas
Present whereabouts unknown
Photo Toninelli, Rome, courtesy of the artist

3 *Les quais*
*(The Embankment)*
1929
Oil on canvas
71 × 58 (28$\frac{1}{2}$ × 23$\frac{3}{4}$)
Collection Pierre Matisse
Photo Pierre Matisse Gallery

4 *La rue*
*(The Street)*
1929
Oil on canvas
129.5 × 162 (51 × 63$\frac{3}{4}$)
Private collection
Photo Pierre Matisse Gallery

5 *La rue*
*(The Street)*
1933–35
Oil on canvas
195 × 240 (76$\frac{3}{4}$ × 94$\frac{1}{2}$)
Collection, The Museum of Modern Art, New York. James Thrall Soby Bequest

6 Detail of *La rue*

7 Detail of *La rue*

8 *Alice*
1933
Oil on canvas
112 × 161 (44 × 63$\frac{1}{2}$)
Private collection, Switzerland
Photo Marlborough Fine Art (London) Ltd

9 *La toilette de Cathie*
*(Cathy Dressing)*
1933
Oil on canvas
65 × 59 (25$\frac{5}{8}$ × 23$\frac{1}{4}$)
Musée National d'Art Moderne, Centre Georges Pompidou, Paris
Photo Jacqueline Hyde

10 *La montagne*
*(The Mountain)*
1935–37
Oil on canvas
250 × 365.1 (98$\frac{1}{2}$ × 143$\frac{3}{4}$)
Private collection
Photo Pierre Matisse Gallery

11 Detail of *La montagne*

12 *André Derain*
1936
Oil on wood
112.7 × 72.4 (44$\frac{3}{8}$ × 28$\frac{1}{2}$)
Collection, The Museum of Modern Art, New York. Acquired through the Lillie P. Bliss Bequest

13 *Portrait de la Vicomtesse de Noailles*
1936
Oil on canvas
135 × 160 (53$\frac{1}{4}$ × 63)
Private collection
Photo Jacqueline Hyde

14 *Thérèse*
1938
Oil on canvas
96.5 × 78.7 (38 × 31)
Private collection
Photo Pierre Matisse Gallery

15 *Portrait de Thérèse*
1936
Oil on canvas
62 × 71 (24½ × 28)
Private collection, Switzerland
Photo Marlborough Fine Art (London)
Ltd

16 *Les enfants*
(*The Children*)
1937
Oil on canvas
125 × 130 (49¼ × 51⅛)
Musée du Louvre, Paris, donation
Pablo Picasso
Photo Musées Nationaux, Paris

17 *Jeune fille au chat*
(*Girl with Cat*)
1937
Oil on canvas
80 × 78 (31½ × 30¾)
Collection Mr and Mrs E. A. Bergman
Photo Pierre Matisse Gallery

18 *Nature morte*
(*Still-life*)
1937
Oil on wood panel
81 × 100 (31⅞ × 39⅜)
Wadsworth Atheneum, Hartford,
Connecticut. The Ella Gallup Sumner
and Mary Catlin Sumner Collection
1938.272

19 *La jupe blanche*
(*The White Skirt*)
1937
Oil on canvas
130 × 162 (51⅛ × 63¾)
Private collection, Switzerland
Photo Borel-Boissonnas

20 *Portrait d'une jeune fille en costume
d'amazone*
(*Portrait of a Young Woman in Riding
Costume*)
1932, repainted 1981
Oil on canvas
52 × 72 (20½ × 28⅜)
Author's collection
Photo Borel-Boissonnas

21 *Joan Miró et sa fille Dolorès*
(*Joan Miró and his Daughter Dolorès*)
1937–38
Oil on canvas
130.2 × 88.9 (51¼ × 35)
Collection, The Museum of Modern
Art, New York. Abby Aldrich
Rockefeller Fund

22 *Thérèse rêvant*
(*Thérèse Dreaming*)
1938
Oil on canvas
150.5 × 130.2 (59¼ × 51¼)
Collection Mr and Mrs Jacques
Gelman, Mexico
Photo Pierre Matisse Gallery

23 *La victime*
(*The Victim*)
1938
Oil on canvas
112 × 194 (44 × 76⅜)
Private collection
Photo Jacqueline Hyde

24 *Larchant*
1939
Oil on canvas
130 × 162 (51 × 63¾)
Private collection
Photo courtesy Electa

25 *Le cerisier*
(*The Cherry Tree*)
1942
Oil on canvas
92 × 73 (36¼ × 28¾)
Private collection
Photo Galerie Claude Bernard

26 *Jeune fille et nature morte*
(*Still-life with Girl*)
1942
Oil on wood
73 × 92 (28¾ × 36¼)
Collection Henriette Gomès
Photo Jacqueline Hyde

27 *Le salon*
(*The Drawing-room*)
1942–47
Oil on canvas
114.3 × 146 (45 × 57½)
From the collection of Mrs John Hay
Whitney

28 *Paysage de Champrovent*
(*Landscape at Champrovent*)
1942–45
Oil on canvas
98 × 130 (38½ × 51⅛)
Private collection
Photo Pierre Matisse Gallery

29 Detail of *Paysage de Champrovent*

30 *La jeune fille endormie*
(*Sleeping Girl*)
1943
Oil on board
79.7 × 98.5 (31⅜ × 38¾)
Tate Gallery, London
Photo John Webb

31 *La patience*
(*The Game of Patience, or Solitaire*)
1943
Oil on canvas
161 × 163.8 (63⅜ × 64½)
The Art Institute of Chicago, Joseph
Winterbotham Fund 1964.177

32 *Les beaux jours*
(*Golden Days*)
1944–49
Oil on canvas
148 × 200 (58¼ × 78¼)
Hirshhorn Museum and Sculpture
Garden, Smithsonian Institution,
Washington DC

33 *Jeune fille en vert et rouge*
(*Girl in Green and Red*)
1944
Oil on canvas
92 × 90.5 (36¼ × 35⅝)
Collection, The Museum of Modern
Art, New York. Helen Acheson
Bequest

34 *L'écuyère*
(*Girl on a White Horse*)
1944
Oil on cardboard
80 × 90 (31½ × 35½)
Collection Thyssen-Bornemisza,
Lugano, Switzerland

35  *Le chat de La Méditerranée*
1949
Oil on canvas
127 × 185 (50 × 73)
Private collection
Photo Jacqueline Hyde

36  *Nu allongé*
(*Nude Lying Down*)
1950
Oil on canvas
133 × 220 (52$\frac{3}{8}$ × 86$\frac{1}{2}$)
Private collection
Photo Jacqueline Hyde

37  *Nu aux bras levés*
(*Nude with Arms Raised*)
1951
Oil on canvas
150 × 82 (59 × 32$\frac{1}{4}$)
Collection Henriette Gomès
Photo Eileen Tweedy

38  *La partie de cartes*
(*The Card Game*)
1948–50
Oil on canvas
140 × 194 (55 × 76$\frac{3}{8}$)
Collection Thyssen-Bornemisza,
Lugano, Switzerland

39  *Nu jouant avec un chat*
(*Nude Playing with a Cat*)
1949
Oil on canvas
65.1 × 80.5 (25$\frac{1}{2}$ × 31$\frac{1}{2}$)
Reproduced by permission of the
National Gallery of Victoria,
Melbourne. Felton Bequest 1952

40  *La chambre*
(*The Room*)
1952–54
Oil on canvas
270 × 330 (106 × 130)
Private collection
Photo courtesy Electa

41  Detail of *La chambre*

42  *Le passage du Commerce Saint André*
1952–54
Oil on canvas
294 × 330 (115$\frac{3}{4}$ × 130)
Private collection
Photo courtesy Electa

43  Detail of *Le passage du Commerce Saint André*

44  *Jeune fille à la chemise blanche*
(*Girl in White*)
*c.*1955
Oil on canvas
116 × 89 (45$\frac{3}{4}$ × 35)
Private collection
Photo Pierre Matisse Gallery

45  *La patience*
(*The Game of Patience, or Solitaire*)
1954–55
Oil on canvas
88 × 86 (34$\frac{1}{2}$ × 33$\frac{3}{4}$)
Private collection
Photo Jacqueline Hyde

46  *Grand paysage aux arbres*
(*Le champ triangulaire*)
(*Large Landscape with Trees*
[*The Triangular Field*])
1955
Oil on canvas
114 × 162 (44$\frac{3}{4}$ × 63$\frac{3}{4}$)
Collection Henriette Gomès
Photo Jacqueline Hyde

47   *Jeune fille à la fenêtre*
(*Girl Leaning on a Window-sill*)
1955
Oil on canvas
196 × 130 (77 × 51)
Private collection
Photo Galerie Henriette Gomès

48   *Jeune fille endormie*
(*Girl Asleep*)
1955
Oil on canvas
115.9 × 88.5 ($45\frac{5}{8}$ × $34\frac{7}{8}$)
Philadelphia Museum of Art. The
Albert M. Greenfield and Elizabeth M.
Greenfield Collection

49   *Nu devant la cheminée*
(*Figure in Front of a Mantel*)
1955
Oil on canvas
190.5 × 163.8 (75 × $64\frac{1}{2}$)
Metropolitan Museum of Art, New
York. Robert Lehman Collection

50   *Frédérique*
1955
Oil on canvas
80.5 × 64.5 ($31\frac{5}{8}$ × $25\frac{3}{8}$)
Private collection
Photo Jacqueline Hyde

51   *Nature morte*
(*Still-life with Cherries*)
c.1956
Oil on canvas
65 × 92 ($25\frac{1}{2}$ × $36\frac{1}{4}$)
Collection Henri Samuel
Photo Galerie Henriette Gomès

52   *Le rêve I*
(*The Dream I*)
1955–56
Oil on canvas
130 × 162 (51 × $63\frac{3}{4}$)
Private collection
Photo Jacqueline Hyde

53   *Golden Afternoon*
1957
Oil on canvas
198.5 × 198.5 (78 × 78)
Collection Henriette Gomès
Photo courtesy Electa

54   *Nature morte*
(*Still-life with Coffee Pot*)
1958
Oil on canvas
73 × 60 ($28\frac{3}{4}$ × $23\frac{1}{2}$)
Private collection
Photo Jacqueline Hyde

55   *Le rêve II*
(*The Dream II*)
1956–57
Oil on canvas
130 × 163 (51 × 64)
Private collection
Photo Jacqueline Hyde

56   *Jeune fille à la fenêtre*
(*Girl at the Window*)
1957
Oil on canvas
160 × 163 (63 × $64\frac{1}{8}$)
Collection Baron David de Rothschild
Photo Jacqueline Hyde

57  *La ferme à Chassy*
(*The Farm at Chassy*)
1958
Oil on canvas
81 × 100 (32 × 39⅜)
Collection Henriette Gomès
Photo Jacqueline Hyde

58  *Jeune fille se préparant au bain*
(*Girl Preparing for her Bath*)
1958
Oil on canvas
162 × 97 (63¾ × 38)
Private collection
Photo Galerie Henriette Gomès

59  *Grand paysage avec vache*
(*Large Landscape with Cow*)
1959–60
Oil on canvas
162.5 × 130 (63¾ × 51)
Private collection
Photo Pierre Matisse Gallery

60  *Grand paysage à l'arbre*
(*Large Landscape with Tree*)
1960
Oil on canvas
130 × 162 (51 × 63¾)
Collection Henriette Gomès
Photo courtesy Electa

61  *Le phalène*
(*The Moth*)
1959
Oil on canvas
162.5 × 130 (63¾ × 51)
Private collection
Photo courtesy Electa

62  *Nature morte à la lampe*
(*Still-life with Lamp*)
1958
Oil on canvas
162 × 130 (63½ × 51)
Musée Cantini, Marseille
Photo Delleuse, Marseille

63  *La tasse de café*
(*The Cup of Coffee*)
1959–60
Oil on canvas
162.5 × 130 (63½ × 51)
Private collection
Photo courtesy Electa

64  *La chambre turque*
(*The Turkish Room*)
1963–66
Oil on canvas
180 × 210 (70⅞ × 82⅝)
Musée National d'Art Moderne,
Centre Georges Pompidou, Paris

65  Detail of *La chambre turque*

66  *Les joueurs de cartes*
(*Card-players*)
1968–73
Oil on canvas
190 × 225 (74¾ × 88½)
Museum Boymans–van Beuningen,
Rotterdam

67  *Japonaise au miroir noir*
(*Japanese Girl with Black Mirror*)
1967–76
Oil on canvas
150 × 196 (59 × 77)
Collection Mr and Mrs Donald
Newhouse
Photo Pierre Matisse Gallery

68 *Japonaise à la table rouge*
(*Japanese Girl with Red Table*)
1967–76
Oil on canvas
145 × 192 (57 × 75½)
Private collection
Photo Pierre Matisse Gallery

69 Detail of *Japonaise à la table rouge*

70 *Nu de profil*
(*Nude in profile*)
1973–77
Oil on canvas
226 × 196 (89 × 77)
Private collection
Photo Pierre Matisse Gallery

71 *Katia lisant*
(*Katia Reading*)
1968–76
Oil on canvas
180.3 × 209.5 (71 × 82½)
Private collection
Photo Pierre Matisse Gallery

72 *Nu au repos*
(*Nude Resting*)
1977
Oil on canvas
200 × 149.8 (78¾ × 59)
Private collection
Photo Pierre Matisse Gallery

73 *Monte Calvello*
1977–79
Oil on canvas
130 × 162 (51 × 64)
Pierre Matisse Gallery
Photo Pierre Matisse Gallery

74 *Le chat au miroir*
(*Nude with Cat and Mirror*)
1977–80
Oil on canvas
180 × 170 (71 × 67)
Private collection, Mexico City
Photo Pierre Matisse Gallery

75 Detail of *Le chat au miroir*

76 *Nu assoupi*
(*Sleeping Nude*)
1980
Oil on canvas
200 × 150 (79 × 59)
Private collection
Photo Pierre Matisse Gallery

77 Detail of *Nu assoupi*

78 *Le peintre et son modèle*
(*The Painter and his Model*)
1980–81
Oil on canvas
226.7 × 233 (89¼ × 91)
Musée National d'Art Moderne,
Centre Georges Pompidou, Paris
Photo Pierre Matisse Gallery

79 Detail of *Le peintre et son modèle*

80 *Untitled*
1981–82
Oil on canvas
163 × 130 (64 × 51)
Private collection, Switzerland
Photo Bétant, Lausanne